West Bend
Art Museum
Collection

Bridget Riley

1 Study for **Persephone I** (pale magenta, blue and green) 1969
Gouache on paper, $22\frac{1}{2}$ in. $\times 25\frac{1}{4}$ in.

Bridget Riley

by Maurice de Sausmarez

New York Graphic Society Ltd.
Greenwich, Connecticut

International Standard Book Number 0-8212-0396-7
Library of Congress Catalog Card Number 73-119591

© Maurice de Sausmarez 1970
Designed by Gillian Greenwood
First published in Great Britain 1970
by Studio Vista Limited, Blue Star House, Highgate Hill, London N19
and in the United States of America
by New York Graphic Society Ltd., Greenwich, Connecticut 06830

Made and printed in the Netherlands by N.V. Grafische Industrie Haarlem

Contents

Foreword 7

Biographical outline 9

1 Introductory observations on optical painting 15

2 The development of Bridget Riley's work 1959-65 26

3 In conversation with Bridget Riley 57

4 Since 1966 86

Notes to the text 120

Exhibitions, collections, awards 121

Bibliography 126

Acknowledgements 127

Index 128

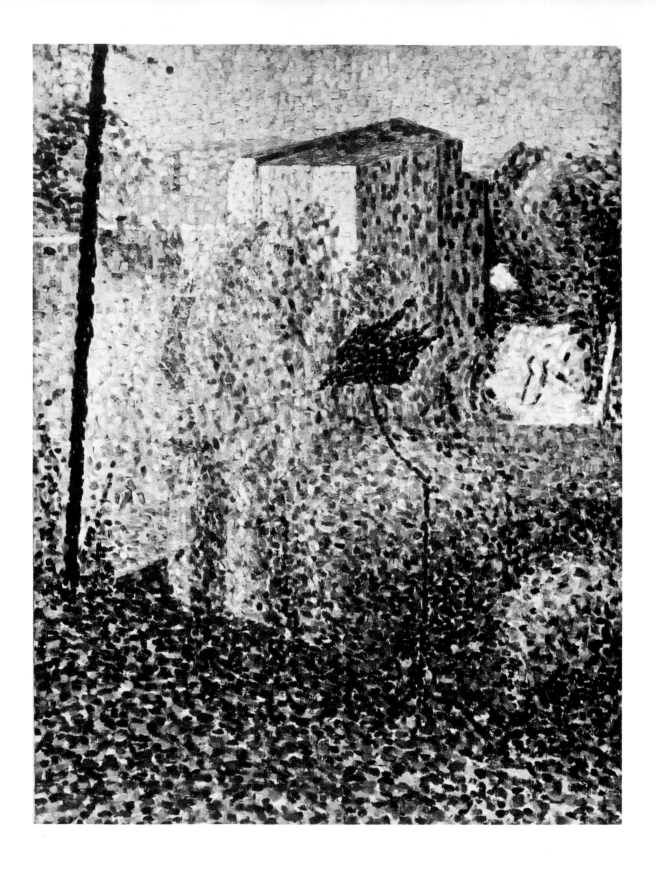

Foreword

The award of the International Prize for Painting at the XXXIV Venice Biennale in 1968 to Bridget Riley came as no great surprise to those who have watched the steady growth in the stature of this artist and the increasing subtlety of her work. But the award, though it may have brought her name before a wider public, will have done little to elucidate the character of her work and talent and to correct the widespread misconceptions of its intentions and its origins. The aim of this monograph is to present a representative selection of her work and an account of her development to date. Take note – 'development to date' – since the appearance of a monograph sometimes has the effect of seeming to present a mould, a public image, which the artist must needs fit as long as the book remains on the shelves.

Riley has made freely available her ideas on her work and ways of working for this book, but she is fully aware that the artist is often the person to whom large areas of the creative process are least accessible for conscious analysis, and therefore ways of working, even modes of creative thinking or 'unthinking' (she has a sense of the penultimate decisions being often arrived at this way), may radically change in the future. In consequence this book is essentially in the nature of an interim report on a continuing development.

M. DE S.

2 **Blue landscape** 1959-60
Oil on canvas, 40 in. × 30 in.
Painted in the studio from studies made near Lautrec in France.

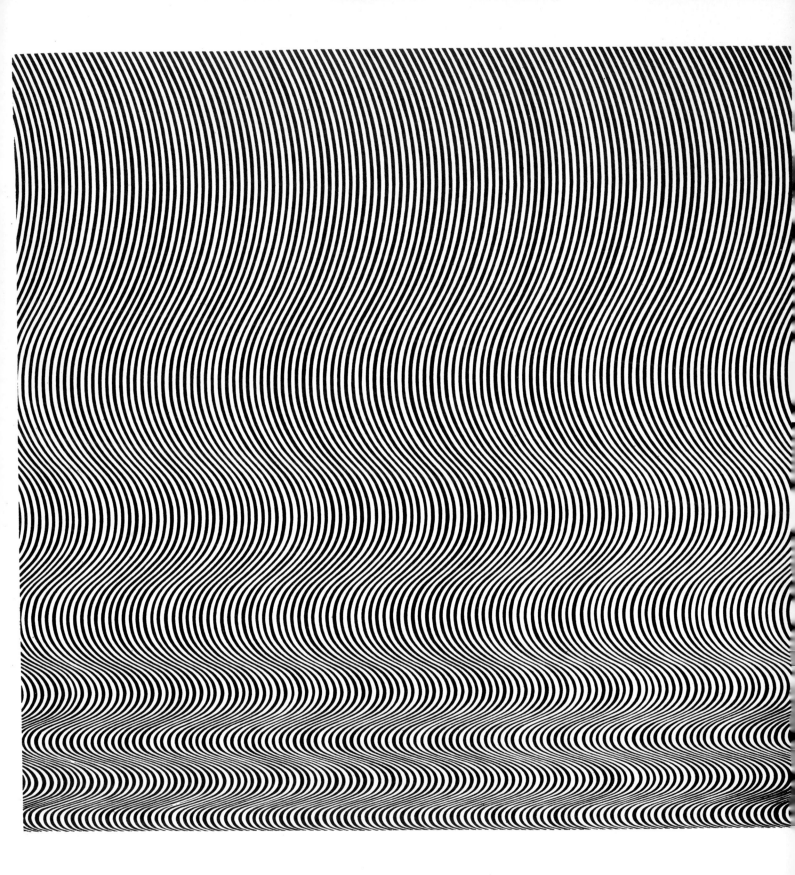

8

Biographical outline

Fall 1963
Emulsion on board,
55½ in. × 55½ in. The
constant here is the
regular spacing of the
intervals between the
lines from side to side;
the length of each curve
in the undulating line that
forms the unit, changes,
diminishes, and provides
the variant. A template
with a serpentine edge of
successively diminishing
curves was made and
the same line drawn
some two hundred and
forty times from top to
bottom at regular
intervals, every alternate
space between lines
being filled in with
black. The increasing
oscillation from top to
bottom reaches a pitch
of powerful intensity, and
total disintegration is
threatened as the eye
loses grasp here, as it
asserts it there.

1931	Born in South London.
1939–45	During the period of her father's absence on war service, lived with her mother and sister and an aunt in a cottage near Padstow in Cornwall. Formal schooling extremely tenuous and spasmodic, but received an intensive visual education, encouraged by the environment and assisted by her aunt, a former art student at Goldsmith's College School of Art.
1946–48	Educated at Cheltenham Ladies' College where allowed to follow her own timetable, the most successful part of her studies being under the guidance of Colin Hayes, then art master at the school but subsequently a tutor at the Royal College of Art, London. From him was acquired an interest in the great traditions of painting, an introduction to the work of Van Gogh, a respect for tonal values and encouragement to draw from the nude in life-classes at the local art school.
1949–52	Studied at Goldsmith's College School of Art, principally under Sam Rabin, who encouraged her enthusiasm for drawing and directed her attention to Ingres's drawings where the concern for achieving a balance of conceptual formal values with those of perceptual logic has been a continuing inspiration.
1952–55	Spent a confusing and frustrating three years in the Painting School at the Royal College of Art, London, with little sense of direction, little contact with her contemporaries, a desire to be free of the incubus of institutionalized studentship but no formed ideas for the self-development of her talent. Awarded the Diploma of Associateship. Represented in Young Contemporaries Exhibition.
1955–56	Nursed her father through a lengthy period of illness, the result of a serious car accident. The mounting psychological strain ended in a nervous breakdown.
1956–58	A period in which almost no painting was accomplished. For a time during 1956–7 she took a job selling glass. The emergence of a sense of direction in her creative thinking was linked partly with The Developing Process Exhibition at the ICA in which she made contact with the ideas of Thubron and Pasmore, and partly with the revelation of American post-war painting in the 1956 exhibition at the Tate Gallery. Self-confidence was further helped by a short period (1957–8) spent in teaching art to children, and a preliminary phase of working in J. Walter Thompson advertising agency (1958–9). Included in Some Contemporary British Painters Exhibition at Wildenstein Galleries.
1959	Attended Summer School in Suffolk directed by Harry Thubron assisted by Maurice de Sausmarez, whom she met for the first time. Immediately afterwards visited Spain and Portugal, and in the following autumn taught in the Basic Course at Loughborough College of Art.
1960	Summer spent in Italy painting (*Pink landscape* comes from this time) and visiting

9

galleries in the company of Maurice de Sausmarez. A deep impression made by the Futurists, in particular Boccioni and Balla; much affected by architecture, in particular the black-and-white buildings at Pisa, the churches at Ravenna, and by the Piero della Francesca frescoes at Arezzo. In the autumn began to teach part-time at Hornsey College of Art in the Department of Fine Art which was then directed by Maurice de Sausmarez, where her colleagues included John Hoyland and Allen Jones. After a brief period of working in a manner close to the 'field-painting' of the Situation movement, made her first essays in optical painting.

1961 In Spring returned to work part-time (illustration, bookjackets and experimental package design) for J. Walter Thompson advertising agency (work which was to continue until 1964). Met Victor Musgrave who arranged for her first exhibition to be held in his gallery the following year. Moved to studio in Earls Court.

1962 First one-man exhibition at Gallery One (April–May). Part-time teaching at Croydon School of Art (until 1964).

1963 Met Anton Ehrenzweig who contributed a foreword to her second one-man exhibition at Gallery One (September) and prepared the first major critical statement about her work for publication in *Art International* in 1965. Awarded prize in open section of John Moore's Liverpool Exhibition, and AICA Critics' Prize, London.

1964 Awarded a Stuyvesant Foundation Bursary. Represented in New Generation Exhibition at Whitechapel Art Gallery; Painting and Sculpture of a Decade Exhibition at the Tate Gallery; Carnegie International, Pittsburgh, and Nouvelles Tendences at the Musée des Arts Decoratifs, Paris. In this year her work was for the first time extensively shown outside England, at Bochum in Germany, in Tokyo, Los Angeles, Buffalo and Cincinatti, and in an Arts Council touring exhibition throughout England.

1965 Her two works in The Responsive Eye Exhibition at the Museum of Modern Art, New York attracted considerable notice and her first one-man exhibition in the USA at the Richard Feigen Gallery, New York, was sold out on the day of opening. Publicly expressed deep anger at the commercialization of one of her paintings by a New York dress firm which manufactured dresses made up from a design of one of her paintings, owned by a director of the firm. Work widely exhibited in major cities of USA and Canada. Represented in British Section of the Fourth Biennale des Jeunes Artistes, Paris. Continued extension of exhibitions of her work abroad. Designed a background projection for T. S. Eliot's *Sweeney Agonistes* at Memorial Performance (June 13), and also the symbol for 'Stage Sixty' at Theatre Royal, Stratford East, London.

1966 Represented in exhibitions of British art in Cologne, Hamburg, Milan, Brussels and in a touring exhibition in New Zealand and Australia (into 1967). Her first exhibition at Robert Fraser Gallery, London (prints and drawings).

1967 One-man exhibition, Richard Feigen Gallery, New York. Represented in mixed exhibitions in England and Ireland, in Buenos Aires and Brussels; also in the Carnegie International at Pittsburgh. Selected by the Arts Council to represent Great Britain, with Phillip King, at the forthcoming 1968 Venice Biennale. Studio residence moved to Holland Park.

1968 Represented in Young British Generation Exhibition in Berlin. Awarded International Prize for Painting at XXXIV Venice Biennale.

1969 Joint exhibition, with Phillip King, of Venice Biennale works at Museum Boymans, Rotterdam. Exhibition of working drawings at galleries in Oxford, Nottingham and Bristol. One-man exhibition of new works, Rowan Gallery, London (July).

4 Fragments no 6 1965
Plexiglass print,
29 in. × 29¼ in.
Belongs to same series
of works as plates 5 and 6

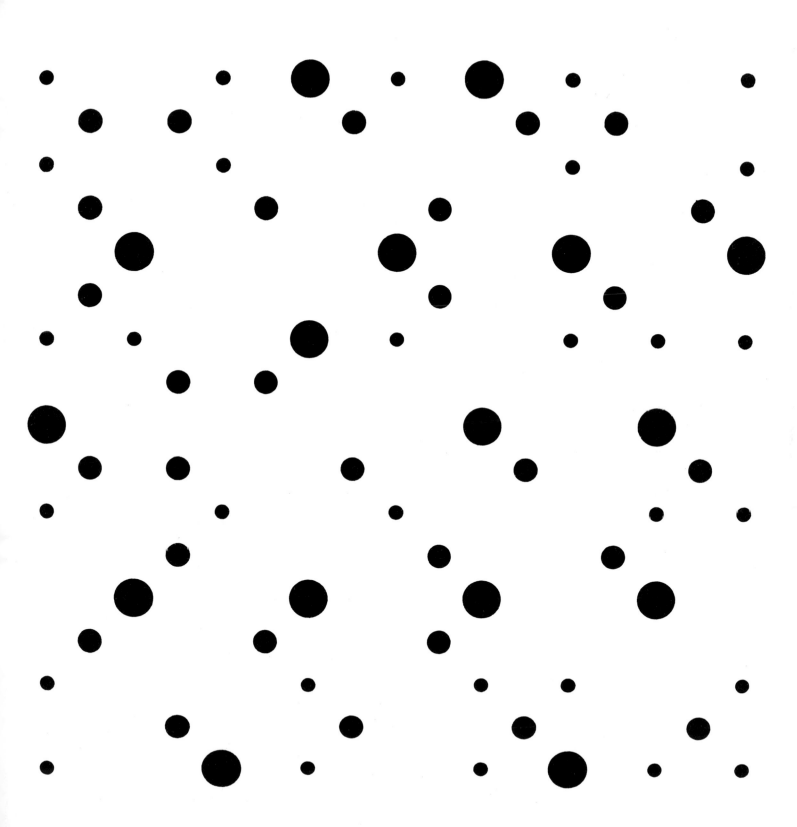

11

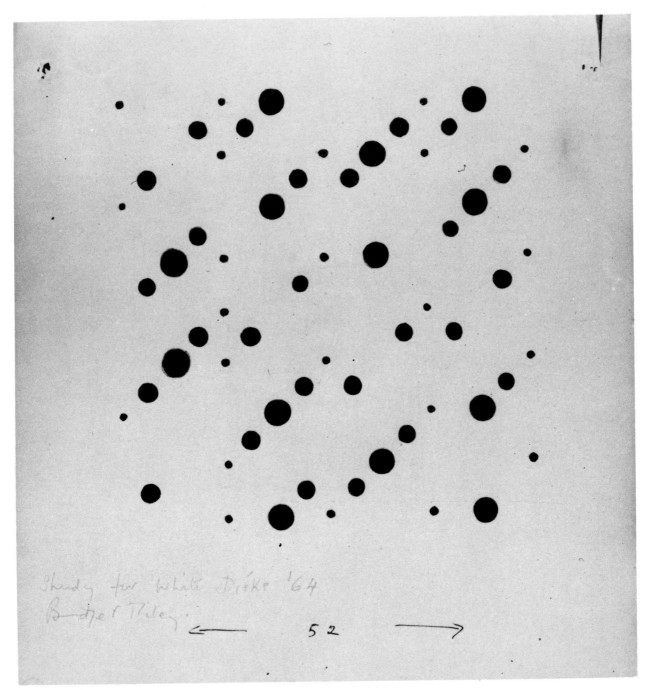

5 Study for **White discs** 1964
Ink on paper, 10⅛ in.×9¼ in.
Has a slight diagonal bias. Throughout the
series the black units are placed so as to give
a random impression, but their organization is
as firmly built as in other works by Riley.

6 **White discs I** 1964
Emulsion on board, 52 in.×52 in.
The title refers to the after-images which appear
like luminous explosions in response to the
stimuli of the black discs. The three sizes of
disc have been carefully selected to generate
different weights of after-image.

13

Introductory observations on optical painting

Few aspects of contemporary art have caused more misunderstanding among critics and public alike than what goes by the name of Op art. It is not that the elements of its artistic language are difficult to comprehend, in point of fact bald geometric abstraction, the keen incisiveness of 'hard-edge' painting and the eye-averting techniques of the graphic arts of advertising and display have long been assimilated. It is more in its creative philosophy and the lack of ease with which it fits into any of the accepted frameworks of either present or past traditions, that it raises special problems. On one level, its decorative potential, through the frequent convergence of dynamic pattern in its manifestations, has been seized upon and widely exploited commercially in 'Op' dresses, 'Op' advertising, and 'Op' packaging, but this has as much intrinsic relevance to the work as the exploitation by a smart interior decorator of *The night watch*'s light and shadow for novelty effects, would have to Rembrandt's initial purpose in using chiaroscuro. Nor have the more serious efforts to place it in the same creative stable as Constructivism been particularly successful, despite the obvious points of contact and reference; nor again can its achievement be shrugged off by shackling it to the field of the experimental psychology of perception, though here again the connection is significant and revealing. And there is little doubt that optical painting can be forced into the category of kinetic art only by falsification of the definition of terms. As a recent book on kinetic art concedes 'Of these three groups (of works concerned with movement) it is the one which is concerned with virtual movement that poses the most difficult problems of classification' [1]. And this difficulty, I suggest, springs from the fact that in the case of optical painting it is not the art that is kinetic but the response to it: the optical 'zizz' occurs in the spectator's receptive sensibility, not in the object. In fact optical painting does not fall within the territory of kinetic art at all; it is an art essentially dependent on sustained meditative visual concentration, and not in any way connected with the mechanisms of physicality.

The most extreme arguments of Constructivism always pointed towards the death of painting. A latter-day Constructivist announced in capital letters that 'The empty canvas symbolizes the fact that this medium can have no more to offer in our times' and in another place he writes 'This medium reached its abyss before Mondrian predicted it' [2]. No-one will deny the Constructivist-realists their right to finish with two-dimensional equivalence in favour of actual form in actual space, but what cannot be sustained is the implication that painting was an art striving always to achieve real space, but which, through its limitations, was forced to make do with illusions of space and solids, and that the only valid statements to-day must be made in real entities, the manipulations of real elements. Some of the essentially non-material space concepts of modern science, or modern ideas of psychological space, would still seem to demand statement in plastic equivalents, where the creative imaginative capacity of the artist and spectator is encouraged to construct psychic and sensational relationships, references implied but not made concrete. For this task, painting would seem to be a

valid medium because of, rather than in spite of, its very ambiguities. Real space and actual tangible form satisfy only part of human consciousness; the poet and the musician still appeal to other levels of mental and emotional experience, other notions of space, and the painted surface, developed and organized in purely visual terms, has an evocative potentiality no less extensive. There is very considerable evidence to support the claim that one important aspect of the profundity and the beauty of the art of painting resides in the implicit dynamism of this sensation of its elements being structured 'spatially' through relationship. The fact that this has been utilized in certain limited periods in the history of art to deliberately trick the eye into experiencing a naturalistic counterfeit of the effects of the visible world has no relevance to the paintings under discussion, just as it has no relevance to the art of Cézanne, or for that matter to the art of Piero della Francesca.

Bridget Riley writes '. . . the fact that some elements in sequential relationship (e.g. the use of greys or ovals) can be interpreted in terms of perspective or *trompe l'oeil* is purely fortuitous and is no more relevant to my intentions than the blueness of the sky is relevant to a blue mark in an Abstract-expressionist painting' [3]. Criticism of her painting based on the failure to see a distinction between *trompe l'oeil* and the integral and implied 'spatial' dynamism of relationship in this two-dimensional art is characteristic of a banal materialism too stuffily doctrinaire and tendentious to be worth serious attention.

But the confusions may have been aggravated by the too frequent use of the expression 'optical illusion' in relation to her work, which calls for some examination. In a *visual* art 'reality' is a specifically *visual* concept and the 'true' and the 'false' are estimated through visual, not physical, measurement.

In 1879 Ewald Hering, the physiologist, distinguished three different kinds of size: retinal size, apparent size and estimated size. Ernst Mach, physicist and psychologist, made a similar point:

> The expression 'sense illusion' proves that we are not yet fully conscious, or at least have not yet deemed it necessary to incorporate the fact into our ordinary language, *that the senses represent things neither wrongly nor correctly.* All that can be truly said of the sense-organs is, that, *under different circumstances they produce different sensations and perceptions.* As these 'circumstances' now, are extremely various in character, being partly external (inherent in the objects), partly internal (inherent in the sensory organs) and partly interior (having their activity in the central organs), it can sometimes appear when we only notice the external circumstances as if the organ acted differently under the same conditions. And it is customary to call the unusual effects, deceptions or illusions. [4]

For Bridget Riley there is no such thing as optical illusion since this would imply the censorship of visual experience by factual measurement. Cobalt blue on a white ground is not the same colour as cobalt on a black ground despite the fact that in both instances the pigment may have been squeezed from the same tube labelled 'cobalt blue'. For Riley *what is visually experienced is the optical reality,* just as in daily life what is physically experienced is the physical reality (because of recent work in theoretical and nuclear physics we do not refer to the world of objects as physical illusion). It becomes abundantly clear that a substantial part of the victory won by modern painting

7 **Kiss** 1961
Tempera on board,
48 in. × 48 in.
One of the overtly symbol
formal structures. The
'blink' or 'flash' in the
white area where the
two massive, sensuous,
black shapes nearly
touch, and the
fractional 'together and
apart' movement of the
straight and curved
dividing lines
distinguish this work
from the 'hard-edge'
school with which it has
sometimes been
associated.

16

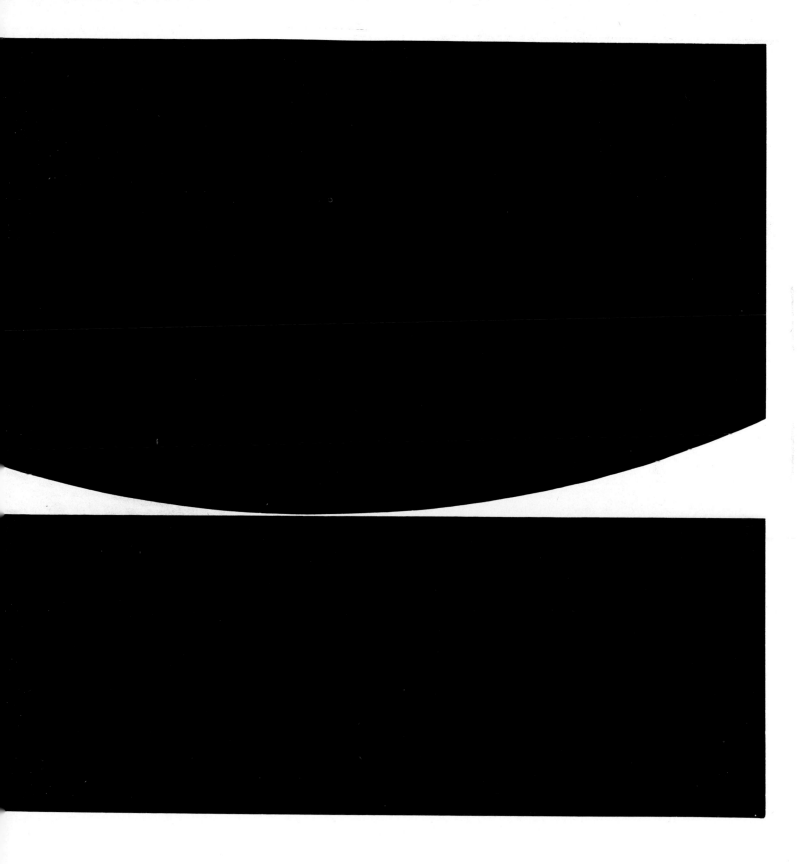

is connected with the vindication of intuitive judgment based on direct sensory experience, and the defeat of the academism that had censored and disciplined sensory responses by reference to purely intellectual theories based on dead, factual, arithmetic measurement, pre-ordained systems and dimensional concepts of balance and symmetry.

The term optical painting which has been used to describe Riley's work, is far from satisfactory, nor have alternatives like 'ophthalmic' or 'retinal' been any more pleasing; efforts to separate the physiological from the psychological responses of the 'eye', the seeing-feeling-thinking complex, in relation to painting have had little support and even less success. And yet it is necessary to emphasize the extent of the role played by immediate neural-retinal response in the concept and form of her painting.

It was this dual impulse, to understand the psycho-physiological responses of the 'eye' and to relate these to a process of pictorial structuring, that excited the attention and continued fascination of Seurat and Signac. And our present interest in the phenomena of visual perception has its firm and established roots back in the nineteenth century, not only amongst the artists but amongst the men of science, Poggendorff, Hering, Helmholtz, Henry, Thompson and many others.

In the 1880s Seurat was being faced with the same criticisms that have at times been levelled against Bridget Riley. Julien Leclerc objected to the 'pernicious confusion of art and science' and another writer stated that 'aesthetics has its own laws, which it must derive from observation, and not predict on the basis of physical experiments'. Arsene Alexandre warned that 'a little bit of science does not do any harm to art; too much science leads away from it' while another critic likened Seurat's paintings to 'coloured rug patterns which housekeepers use for slippers'.

Bridget Riley has written: 'I have never studied optics and my use of mathematics is rudimentary and confined to such things as equalizing, halving, quartering and simple progressions . . . I have never made use of scientific theory or scientific data, though I am well aware that the contemporary psyche can manifest startling parallels on the frontier between the arts and the sciences.' [5] Nevertheless, the relationship between science and art is particularly thrown into relief by Riley's form of painting, which reduces the material evidences of personal involvement to a minimum in the interests of an objective evaluation of the interaction of the energies inherent in the related lines, colours and shapes, and utilizes calculated intervals, frequencies and elements, in such a way that there might at times appear to be a resemblance to scientific diagrams. Further, it is frequently demonstrating principles which, though they may not be defined, are nevertheless as evident as the physical laws that underlie scientific enquiry and deduction. But it is not so much the apparently scientific detachment that worries the average spectator, as the apparent remoteness of the artist from the process of materialization, the feeling that the works might be produced by machines.

There is a sequence in Mondrian's essay in dialogue form, 'Natural Reality and Abstract Reality', which bears directly on this issue:

x But isn't the hand of the artist everything?

z You are thinking in terms of the old art, in which the hand of the artist was, in fact, everything – precisely because in the old art, the individual element plays such an important part. In the old art, the universal remains under a veil. The new art requires a new technique; exact plasticism requires means that are exact . . . [6]

8 **Pink landscape** 1959 Oil on canvas, 40 in.×40 in. Painted near Radicofani overlooking the vast plain subjected to intense heat-haze and shimmering light. Pointilliste technique exploded to the stage where the individual *pointilles* have become so large as to take on the character of separate 'form-units' (for comparison refer to Balla's *Girl running on balcony* 1912). The entire visual field has been consistently developed in this way, giving rise to the continuous fluctuating unorientated space that characterizes later work in particular recent paintings like *Late morning*.

18

Mondrian's commitment was to a belief that 'through contemplation . . . the existence of anything is defined for us aesthetically by relations of equivalence . . . In terms of composition the new plasticism is dualistic. Through the exact reconstruction of cosmic relations it is a direct expression of the universal; by its rhythm, by the material reality of its plastic form, it expresses the artist's individual subjectivity. It thus unfolds before us a whole world of universal beauty without thereby renouncing the human element.' [7] Like Mondrian, Riley believes that through relationship contact is made with extra-personal forces and energies, universal factors, while the element of subjectivity is retained on the level of individual-formative decision. Her painting is committed to the thesis that calculated relationships brought to a precise point of tension bring into being, or liberate, a field of energies that reveal a new dimension of experience and beauty. But even if we discount Mondrian's metaphysical tendencies, there is yet another hint in his early statements of the belief that sustains Riley's work. In a notebook of 1910/11 he wrote: 'There is a cause for everything, but we do not always know what it is. To understand, to know – there lies happiness.' [8] The inquisitiveness that accompanies speculative thinking must seek out the terms for the demonstration of its suppositions, and not infrequently this demands a rigorous paring down to fundamentals. And it is in the precision of the sustained enquiry that Riley's painting seems to parallel scientific analytical procedure. But is it a sustained form of enquiry, and, if so, what is the nature of its enquiry?

There is a fundamental difference between the scientist's concern with things as agents producing effects, the imperative allegiance to causal systems, and the artist's concern with things for their own sakes. 'The artist is not committed to an inexorable rule of logic imposed from without on the matter in hand, he has to discover afresh in each work the logic peculiar to it. Only to a limited extent does the completion of a work provide him with a general hypothesis applicable to future problems . . . The problem during the process of making is always "how can this thing be made perfectly as a thing expressive in itself and in conformity with its own nature?" ' [9] A clear distinction can be drawn between the scientist's desire to find answers to what happens and how things happen and the artist's satisfaction with the simple demonstration that they do happen and that they can extend the range of man's consciousness and aspirations. Bridget Riley says of her work 'I work from something rather than towards something. It is a process of discovery . . .'

Would this form of painting's pursuit of optical responses (its concern with the physiological mechanism of the eye) alone, be sufficient to justify the claim to its being art? No more than the pursuit merely of naturalistic verisimilitude qualifies as art. The justification lies in the fact that this enquiry into the field of optical dynamism is placed at the service of a faculty of informing that seeks to create totally structured coherences that minister both to our human need for controlled experience and expression, and to the deeper level of unverbalizable responses that are rooted in the psycho-physiological nature of our being. Charles Blanc wrote: 'If there is a great affinity between light and dark and emotion, there is even more between emotion and colour; straight or curved, horizontal or vertical, parallel or divergent, all lines have a secret relation to emotion.' [10] And Paul Serusier has stated 'Thoughts and moral qualities can only be represented by formal equivalents. It is the faculty of perceiving these correspondences which makes the artist.' [11]

9 **Movement in square**
1961
Tempera on board,
48 in.×48 in.
Retains the overall structure design of *Kiss* but substitutes a repeated unit, the white and black square, for the uniformly black areas. The square is serialized in its progressively compressed movement from left and right, reaching a vibratory climax at the point of contact. This resulting optical disruption indicates a source of energy which becomes the central feature of subsequent work.

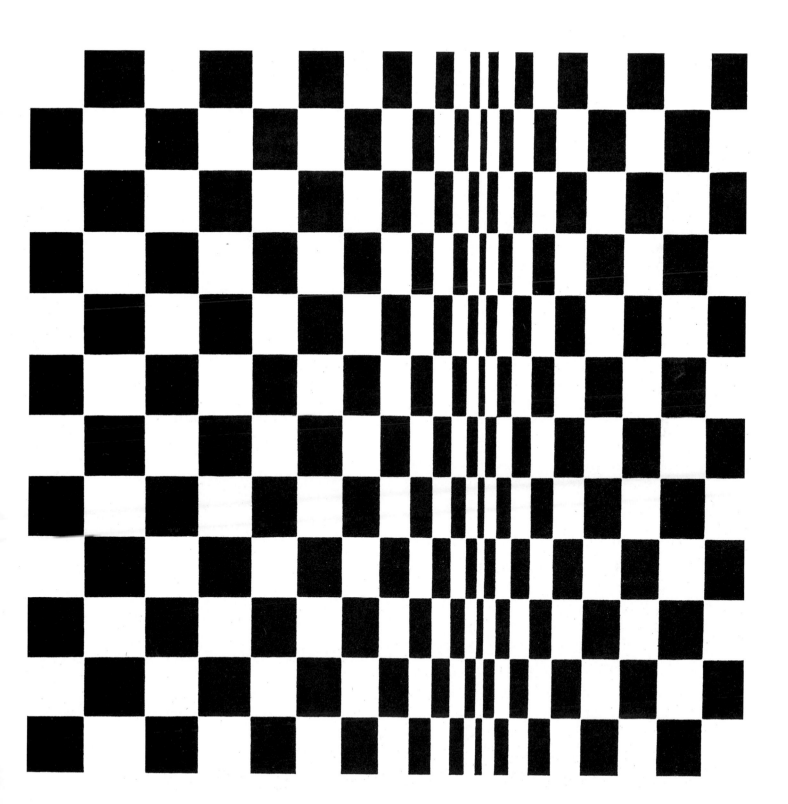

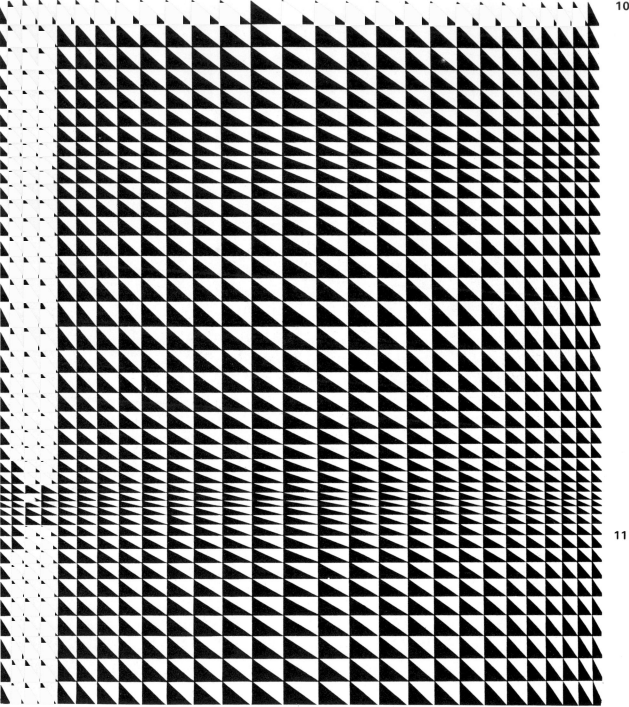

10 Straight curve 1963
Emulsion on board,
28 in. × 24¼ in.
The total field is subject
to a sequentially
changing set of vertical/
horizontal relationships,
which has a consequent
continuous effect on the
basic unit, formed by the
diagonal halving of the
separate component
parts of the grid
produced by the vertical
horizontal lines. The
principle of compression
and expansion thus
operates over the entire
field, resulting in
changing speeds both in
the unit and in the
structuring from side to
side and top to bottom.
Curving movements
miraculously make their
appearance as the eye
scans the structured
field. See Anton
Ehrenzweig *The
hidden order of art*
London, 1967.

11 Hidden squares 1961
Tempera on hardboard,
36 in. × 36 in.
The 'hidden squares'
have the same
dimensions as the
horizontal and vertical
dimension of the circles
This is the first time that
Riley uses a buried
image, a device popular
with the Pointillistes.
This painting led to
*Opening, Fugitive,
Tremor*, etc.

12 Black to white discs 1961-2
Emulsion on canvas, 70 in. × 70 in.
First painting in which tonal sequence assumes a role, as the variant to a constant structure of regular circular units. From an off-centre vertical row of black discs, gradated tonal sequences move away at different rates to left and right, reaching near white at each extreme disc. This painting has much in common with *Search* and *Late morning.*

13 Opening 1961
Tempera on board, 40 in.×40 in.
The increase/decrease of the black verticals
implies a lozenge form, which later became the
area format in *Serif, Crest* etc. The tonal
differentiations thus achieved were extended in
Tremor and *Fugitive*.

The development of
Bridget Riley's work 1959-65

One of the basest forms of deception practised in art criticism is to present the major artists as having sprung fully armed and tactically prepared into the creative arena: we know it to be false in every case. Far from diminishing the achievement of an artist, the account of his early struggles to clarify and develop his talent adds to his stature and increases one's respect for the strength of his creative will.

My first visit to Bridget Riley's studio, which was then in a terrace house off Fulham Road, was in the summer of 1959. In that large first-floor room with its two long windows overlooking gardens, there was proof enough of the desperate struggle she was having to find some firm ground for the development of her work, following an enforced break of nearly three years. The fact that she had fairly recently had some work included in a mixed exhibition at the Wildenstein Gallery could not disguise the nature of her dilemma. Around the walls stood some largish canvases much influenced by late Matisse, and on the easel, one of a group more recently finished, a rich still life showing love and understanding of Bonnard. In folios was a mixture of strong incisive drawings from the nude, the outcome of her veneration for Ingres, some studies in oil-crayon dense in colour, linked with her prevailing interest in Bonnard, and landscape drawings mainly of Lincolnshire, where her parents then lived, the colour delicately indicated in pastel flecks or dots, superimposed to obtain mixtures in the manner of Signac, premonitory of later optical developments. None of these influences, explored with a mounting sense of desperation, was to prove wholly irrelevant to her later work, although the way forward was at that time entirely unknown and unpredictable.

In the spring of the following year I had to prepare three lectures on Futurist painting to be given at the Royal College of Art, marking the fiftieth anniversary of the publication of the Futurist Manifesto on Painting. I found in Bridget Riley a willing collaborator but I did not realise at the outset, nor perhaps did she, how much our discussions and arguments, analyses and criticisms might help to clarify some of her own most fundamental problems. But I can remember the intense expression of agreement that followed my reading of a quotation from Severini: 'It is only a small step from art to absurdity – disorder and the arbitrary have never resulted in the construction of a work of art . . . All philosophies tending to separate the body from the mind are anti-scientific and seem to me absurd. The job which we as artists have to accomplish to-day is to establish an equilibrium between intelligence and sensibility.'

As an outcome of our discussions the role of Seurat became increasingly dominant and it must have been about this time that Riley undertook a full-size copy of a Seurat in the Courtauld Institute collection, *Le pont de Courbevoie*. The idea of making a point-by point copy of a work to study its structure or to prove to oneself the rightness of one's assumptions about its genesis, is one that is not easily accomodated by a public fed on the myth of 'instant' genius. It is a salutary thought that Mozart, reputedly the most self-sufficient genius, spent hours transcribing Bach Preludes and Fugues for string quartet in order to understand more fully their contrapuntal profundities and to develop

his own capacity for string ensemble writing. In like manner Riley's understanding of Seurat was increased and she was anxious to make contact again with the sources of his theories: Charles Blanc, Chevreul and Charles Henry. However, there were no English translations of Henry, Chevreul last appeared in English in 1872 and Blanc in a Chicago version of 1879. All would have re-enforced her creative thinking and would have given her the renewal of confidence she so badly needed, but William Innes Homer's informative book *Seurat and the science of painting* did not appear until four years later. She was now installed in a large top-floor studio in Earls Court where, for a time, the walls were covered in fragments of colour theory, an enlarged commercially produced three-colour half-tone of some apples with the colour dots the size of cherries, and, in the kitchen, a big reproduction of Seurat's *La grande jatte.*

That summer we spent together moving about Italy, partly making notes and studies of landscape and partly visiting the major centres, galleries and architectural monuments. In terms of Riley's own painting, one major work dates from this Italian journey, *Pink landscape* (see p. 19), which was painted from the experience of a stretch of landscape in the hills south of Siena, drenched in a blinding shimmering heat-haze that ended in one of the fiercest storms of that summer. It is something of a talisman being the first painting which registers as part of subsequent developments and, as David Thompson later remarked, it is 'already concerned with a kind of optical situation which constantly recurs in her later work – that of a dominant formal pattern under pressure of disintegration . . . As a painting about making pure colour convey visual shimmer, it is a direct precursor of *Late morning* [1967/68].'

The opportunity to see Futurist works at first-hand was everywhere seized (as indeed was the opportunity to see Severini, though the visit to Cortona proved unavailing, he had suffered a heart attack the night before our arrival). Just prior to our return to England we visited the Venice Biennale. The central galleries were devoted to a comprehensive showing of Futurism, 143 major works having been assembled. Perhaps the deepest impression was made by the work of Balla, in particular such works as *Girl running on a balcony, Dynamic penetration of an automobile* (the decisive thrusting structuring and its pervasive black/white astringency may have unconsciously been partly formative of the group of dramatic new works that Riley was to produce on return to England) and *The iridescent interpenetration*, which was recalled to memory eight years later in the solution of a problem. Influential too was the experience of the black and white architecture of Pisa, the structure and proportion of many other architectural works, and the Arezzo frescoes of Piero della Francesca seen to the accompaniment of choral music sung to commemorate the birth of Guido d'Arezzo (*c.* 990– *c.* 1050), founder of the modern measured system of musical notation.

On return to London I was able to suggest a small part-time teaching assignment for Riley at Hornsey College of Art where I had recently assumed direction of the Fine Art Department. I had already been fortunate in bringing together a team that included John Hoyland, Peter Cresswell, Bill Culbert, Neil Stocker, Allen Jones and the distinguished art-historian Arnold Hauser, and among the students in the department were Roland Piché, John Edwards and Derek Woodham. It was a challenging situation and for a period of three to four months the ideas of the Situation group, which seemed to her the only serious movement to which her interests could relate, diverted Riley's attention to figure-field problems. But, characteristically, the very few paintings in this vein were far more concerned with visual energies, or optical disturbance brought

into play: for example, the oscillatory vibrations in *Kiss* experienced in the area of the white shape as the two massive sensuous black forms slowly and softly come together (see p. 17). Before the end of the year Riley had found not only a special territory for the full development of her talent but also the precise terms in which her statements could best be made.

Interest is always expressed in defining the point at which an artist discovers his own original field, and in the case of Riley a particularly rewarding comparison can be made between *Kiss* completed in late 1960 and *Movement in squares* (see p. 21) painted early in 1961. If the former is viewed on its side so that the two massive black shapes operate their pressures from left and right, instead of from top and bottom, we see that *Movement in squares* is concerned with the same phenomenon. So too is *Fission* of 1962 (see p. 69), but in the first case the two forces have been represented by diminishing squares and in the second by progressively compressed circles. I believe that it was with the completion of *Movement in squares* that Riley's future development was confirmed.

1961 was a year of prodigious activity. Her new-found clarity of aim gave her an ability to work at astonishing pressure and the rich discoveries to be made through the utilization of comparatively few structural ideas gave added zest to her work and resultant power through the limitation of means. At this time these structural ideas included modulation of contrasted form units, displacement in an otherwise regular progression, a shifting centre within a circular form and dramatic tensions in a zig-zag rhythm. The strength of the optical dynamism unleashed in these structurings was a source of continued astonishment, as was the realization that this activity was subject to its own inherent laws and disciplines. The scale of the units and the total structure was conditioned by the type and intensity of the energies seeking to operate, and these could not be predicted apart from the actual experience of seeing a fragment enlarged; the speed, the apparent quickness and slowness of the structured movement, was controllable; the number of changing events in form which the eye could accomodate without a disintegrative fluidity resulting, was limited; multi-coloured forms were not as conducive to this particular formal argument as black and white, the richest yet simplest complete binary system. Later in this year, 1961, Riley saw reproductions of work by Vasarely for the first time, and realized that her own recent work had long been anticipated by this master; far from being in any way discouraged she was greatly sustained by this knowledge, and keen to pursue an independent development.

By one of those astonishingly prophetic coincidences Bridget Riley found herself one evening, during a heavy rainstorm, sharing the shelter of a shop-doorway with Victor Musgrave, director of Gallery One, whom she had never previously met. It was not an unusually lengthy storm but by the end of it an arrangement had been reached for her to show him some work, and the subsequent outcome was the promise of a one-man show in the Spring of the following year. Musgrave was an unusually perceptive director fearlessly prepared to back his judgment; during its ten years of existence the gallery added an exciting unpredictibility to a scene that all-too-frequently settled down to identifiable closed 'house styles' leaving scarcely a crack through which new talent can demonstrate its existence. With Riley, Musgrave was really 'chancing his arm' because, with the exception of the few studies influenced by Bonnard that had been shown in a mixed show at Wildenstein's nearly three years earlier, she had exhibited nothing in the West End, yet he was prepared to offer her a complete one-man show. I was

invited to contribute the introduction to the catalogue and already I had clearly distinguished the distance that separates her work both from kinetic art and optical illusion; I wrote:

> Dynamism here is neither the description of movement nor the record of actual physical movement, it is poetic and arises from the pure relationships of the pictorial elements used. The marks and shapes on the canvas are the essential agents and the sole agents of a primarily visual sensation. The paintings act like electrical discharges of energy making immediate contact with our neural mechanism. Bridget Riley treats what has been termed 'optical illusion' as a 'real' system of visual dynamics. . . But these works are not to be explained as demonstrations of a theory of perception; in addition to their teasing ambiguities, they have a lyricism, a structural strength, an immaculate and vibrating freshness that is the clearest evidence of a creative sensibility, an acutely refined judgment.

The exhibition contained nine works, including *Black to white discs* (nearly 6 ft square), *Movement in squares* (4 ft square), *Horizontal vibration* and *Hidden squares*, all works that have proved of seminal importance. The problems set in these works are of a formal nature resulting in powerful perceptual effects; in some cases it can be characterized as a single disruptive event, ocurring as the summation of regular permutations of the formal units and their spacing (see *Movement in squares* p. 21, *Horizontal vibration* p. 114, *Hidden squares* p. 23, and *Tremor* p. 65), in others as the almost imperceptible displacement of one set of units by another, subtly changed, set so that one structured situation is buried in another (*Hidden squares* and *Tremor*), or again as the visual disorientation resulting from shifting the centres of implied cyclical structurings within a circle (*Circle with a loose centre*), or yet again as progressions of one unit through a transforming tonal scale (*Black to white discs* p. 24).

There was no relaxing of the pressure of work and already, before the termination of this first show, there were new developments to be seen in her studio which gave confident hope of a follow-up exhibition in 1963. It was natural that Riley should feel at this point an urgent need to test out to the maximum the strength of the visual energies that were being invoked in her work, and it is from the paintings of 1962–3 that the notion developed that her work was concerned with violence and with the exploration of retinal disturbance pushed to the limits of endurance, even to nausea itself. Certainly the preparations for the 1963 exhibition included a structured physical space, *Continuum* which could be systematically 'destroyed' by the force of visual energies organized in a continuing visual band across its containing surface. But from the outset this was approached essentially as a 'clinical' experiment, and, as in the case of so many works from this particular period, the intensity of the optical disturbance, its violence, should not be interpreted as a central or continuing feature of Riley's aim or achievement. With the help of Peter Sedgley, whom Riley had come to know during the year, the structure of *Continuum* was built 6 ft 10ins x 12ft x 28ft convoluted in form like the interior of a shell and painted with emulsion, the progressions of lines and spacings being so dislocated that the experience of being inside was a *total* breakdown of one's physical orientation and capacity for estimating both distance and space, an hallucinatory experience that could be tolerated for only a few minutes without a sense of distress (see p. 32). Having, as it were, proved her point Riley never again resorted to this form of optical assault.

Anton Ehrenzweig, well-known for his work in the psychoanalysis of aural and visual perception, expressed a keen desire to meet Riley and a meeting took place in the summer of 1963 at her studio where he was able to see the bulk of the new work. He was immensely impressed and offered not only to join David Sylvester in contributing a foreword to the catalogue of the forthcoming exhibition, but also to prepare a critical essay for subsequent publication in *Art International* (the interrelatedness of these two 'essays' is immediately apparent, although the *Art International* article did not appear until February 1965). In the catalogue introduction Ehrenzweig wrote:

One can distinguish two contrasting phases on the experience of Bridget Riley's paintings – the first phase can be called cold, hard, aggressive, 'devouring', the second warm, expansive and reassuring. We sometimes speak of 'devouring' something with our eyes. In these paintings the reverse thing happens, the eye is attacked and 'devoured' by the paintings. There is a constant tug-of-war between shifting and crumbling patterns but at a certain point this relentless attack on our lazy viewing habits will peel our eyes into a new crystal-clear sensibility. We have to submit to the attack in the way in which we have to learn to enjoy a cold shower bath. There comes a voluptuous moment when the senses and the whole skin tingle with a sharpened awareness of the body and the world around.

Ehrenzweig also noted a phenomenon that increasingly began to appear in many of these black and white works: 'strangely iridescent disembodied colours, like St Elmo's fires, may begin to play around the centres of maximum tension' (see *Crest*, p. 43 and *Shuttle*, p. 55). This phenomenon of the appearance of iridescent disembodied colours was to become of even greater significance from 1967 onwards in the works in colour.

Whereas the 1962 exhibition had been largely of works in rectangular format, the 1963 show in September of that year was to some extent dominated by circular formats (see *Uneasy centre* p. 45, *Interrupted circle*, *Broken circle* p. 49, *Dilated centres*, *Blaze* 1 p. 51 and *Blaze* 2). They all have the appearance of being variations on a theme, the theme having been announced in *Circle with a loose centre* from the 1962 show, disruption through an internal spiralling movement consequential upon shifting the centres of the circular forms involved. Without being aware of it, Riley was making contact with a field of scientific enquiry stretching back into the nineteenth century to the work of David Brewster and Silvanus Thompson (his strobic circles) on the mechanism of the visual after-effect of movement, and through to the recent 'ray' figures of D. M. McKay. At this time, astonishing though it may seem, she was even unaware of Duchamp's rotor-wheels. The Riley variations are a powerful group of works and the *Blaze* variants were quick to establish themselves, together with *Fall* and *Current*, as the most frequently reproduced examples of her work.

The use of the term 'theme and variations' immediately brings into focus the relevance of the musical analogy and I have recently, in writing about Riley's studies and drawings, pointed to the fact that from the very first her work has been concerned with factors of modulation, progression, rhythmic range, changes in tempi, consonance and dissonance, and relations between intervals, all concepts more usually associated with music. And it was while considering this relationship that I came across a passage in an interview with Stravinsky where the composer had spoken of musical form as being close to 'something like mathematical thinking and mathematical relationships. (How misleading are all literary descriptions of musical form!) I am not saying that composers

think in equations or charts of numbers, nor are those things more able to symbolize music. But the way composers think, the way I think, is, it seems to me, not very different from mathematical thinking ... But though it may be mathematical, the composer must not seek mathematical formulae ... Seurat said "Certain critics have done me the honour to see poetry in what I do, but I paint by my method with no other thought in mind".' [12] It is a statement that might equally well have been made by, or of, Riley.

At the time of writing his article 'The Pictorial Space of Bridget Riley' (*Art International*, February 1965), Anton Ehrenzweig was excited by the extent to which optical painting threw a spanner in the well-oiled wheels of *Gestalt* psychology, its 'constant tug-of-war between shifting and crumbling *Gestalt* patterns' that so effectively frustrated simple balanced organization. The dazzle effects defeated the attempts at focusing and resisted efforts to find an easy accomodating stability. He was already at work on his perceptive study *The hidden order of art*, completed shortly before his death in 1966, in which he wrote:

Like serialization in music, optical painting is a case of the intellect destroying its own modes of functioning. The single elements of an optical composition are serialized in so smooth a gradation that the eye fails to pick out any stable *Gestalt* pattern...
Our vision is conditioned to give up focusing and to take in the entire picture plane as a totality. It is at once directed to highly mobile and unstable patterns of pictorial space and its fluttering pulse. In this manner the initial total intellectual control of optical serialization leads without transition directly to the experience of uncontrollable pictorial space. [13]

In discussing her way of building the serialized structure of her work at that time, Riley distinguished the following stages (not all are necessarily involved in any particular work):

1 *establishment of the unit:* the discovery of a unit that lends itself to serial transformation.

2 *intensification of contrast:* the unit is submitted to a variety of transformations, according to the principles of serialization, that display its dynamic potentialities (e.g. expansion/contraction, acceleration/deceleration, directional tilting, inversion etc.).

3 *climax:* the arrival at maximum 'energy' involvement.

4 *split or dislocation:* the threatened destruction of the picture plane.

5 *return:* the process of de-escalation through a form of recapitulation in order that the cycle of serialization be brought to a close.

Of paramount importance is the question of *scale*; the choice of scale both of the unit and the total field over which it will operate is crucial. The unit must be neither so big as to become a separate entity nor so small that in a cluster it disintegrates or fuses; the total field needs to retain, when fully developed, a scale that enforces complete visual emersion.

But none of this has meaning apart from a final unpredictable total transformation and the emergence of a 'presence', a sort of hallucinatory experience. It is this mysterious 'presence', this total hallucinatory revelation that matters to Riley; unless this emerges finally, the work, however intriguing its optical display, has failed.

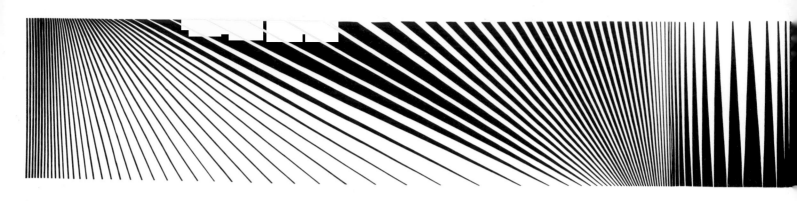

14 Study for **Continuum** 1964
Ink, pencil, collage on paper,
28⅜ in.×134⅛ in.
One of the final pair of drawings for
Continuum, for the lower half of the
arrow/diamond unit. It accelerates and
decelerates at different tempi.

15 **Continuum** 1963
Emulsion on board, wood frame, seven
sections, 6 ft. 10 in.×28 ft.×12 ft.
An aerial view of the model, the
spectator walks in from the left. See
Norbert Lynton 'London Letter,
Bridget Riley' *Art International*
October, 1964.

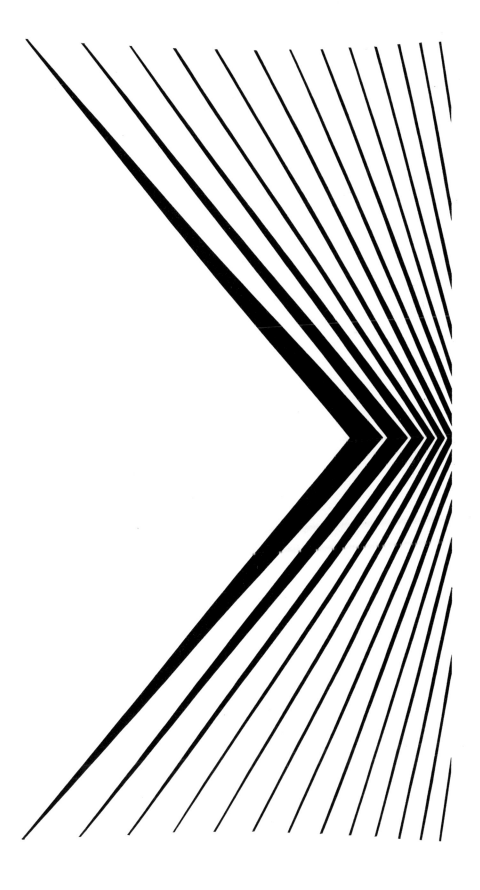

16 Panel 1 of **Continuum**
The first of the seven curved panels of
Continuum.

If the 1963 exhibition was a demonstration of the distance that now separated her preoccupations from those of Vasarely, her visit to America in 1964 made Riley realize the distance that separated her from the prevailing American scene. Three years earlier the sloppy after-math of Abstract Expressionism (whose major masters she greatly admired) and the disintegrating effects of its widespread misrepresentation, made her commitment to clarity an imperative and urgent demand. Looking back on it, this was in some ways a parallel to the American emergence of 'cool', not like it in terms of content, but in terms of creative lucidity. She was aware that in some respects her concept of space, as an open shallow multi-focal space, and of surface, as a fluctuating unorientated field, had affinities with the concepts of painters like Mondrian ·in his *Broadway boogie-woogie* period (she had made a careful copy of that work earlier) and Pollock, but she found herself out of sympathy with the emerging tendencies in American painting towards an aesthetic of reduction. Art was being invaded by concerns often more properly belonging to philosophy, and the sort of philosophical extrapolation which minimizes to the point of intellectual essence is of dubious value to the creative artist: in terms of the transmutation to the physical media, the resultant work has the sense of being finished before it has begun. For Riley there was no substitute for the perceptual experience as a developing process, nor could it be savoured, estimated or summarized in advance.

Her work, for the first time, was being shown extensively abroad, in Germany, in Paris and Tokyo, in Los Angeles, Buffalo and Cincinnatti, in addition to its inclusion in the Carnegie International at Pittsburgh, and arrangements were made for her first American one-man exhibition to be held at the Richard Feigen Gallery, New York, in March of the following year.

William Seitz's omnibus Op Art show at the New York Museum of Modern Art under the title 'The Responsive Eye' opened about a week before Riley's own show at Feigen's. It contained two of her works, *Current*, which was chosen for the cover design of the catalogue, and *Hesitate*. From the first her paintings excited a great deal of interest and admiration, but the extent of the success of her own show could not have been predicted from this initial response. On the opening day at Feigen's Gallery all sixteen works on exhibition were sold and a waiting list compiled of collectors anxious to have one of her works. It was a phenomenal success measured by any standards. But pleased as she was by this acclaim, she was distressed by the fierceness of American art-politics, the acrimonious squabbling of critics that centred round 'The Responsive Eye' show, and deeply angered by the unrestricted commercialization of works by living artists. She herself was suffering at the hands of a dress firm that used one of her paintings, owned by a director, as the fabric design from which they made-up topical 'Op' creations. In America at that time there was no protection for the artist.

Back in London, work was quickly resumed and, as if to create an even greater distance between her work and the over-stimulated atmosphere of the New York scene, the importance of the use of greys in her work increased to achieve subtler and slower changes of speed between black and white extremes. Although basically the formal structuring of many of the new works remained substantially unchanged, a new argument was introduced between form and tone, but for her future development the major significance lay in the fact that the addition of the polarities of 'warm' and 'cold' in the greys was an augury of a move towards colour (see *Arrest* p. 92, *Search* p. 80, *Drift* p. 93 and *Deny* p. 77).

17 **Hero** (Ascending and Descending) 1963-5 Emulsion on canvas, 72 in.×108 in. The central points of the horizontal elongated triangles rise, reverse and rise again, implying a vertical. This movement is emphasized by the changes in scale.

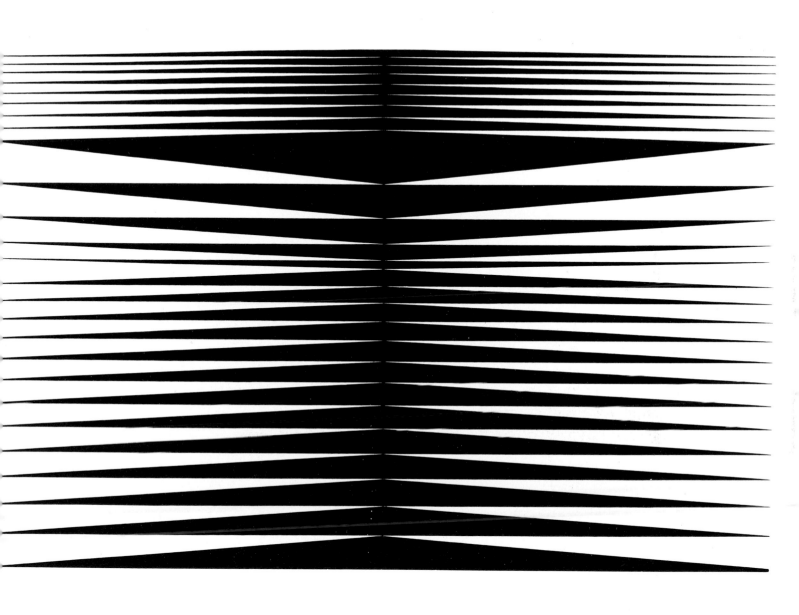

Make a similar transition
between F-7 a bright one

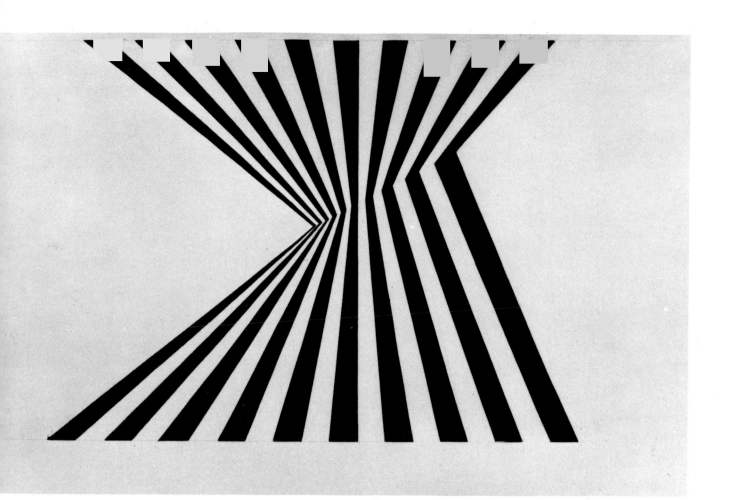

Study 1963
Ink and pencil on paper,
22⅛ in.×14 9/16 in.
Illustrates clearly the emergence of a
dense black irradiative diagonal curve
from a structure entirely formed from
hard straight edges. The changes in
speed across the field are accompanied
by a rising movement of the variable
point in the triangular units. The
finesse in controlling the movement of
the spectator's eye is exemplified in an
aide-mémoire written at the base:
Make a smoother transition between
5 and 7'. Related to *Hero* but never
carried further as a painting.

19 Untitled study for print 1964
Ink on paper, 17 in.×24 5/16 in.
Classic example of energy produced by
the simplest means: ten black bands
set out at top and bottom, with a
regular intervallic relationship in each
case, are joined to a radically com-
pressed diagonal directional line, in
which the intervallic relationship
changes to a sequence of progressively
increased measurements.

37

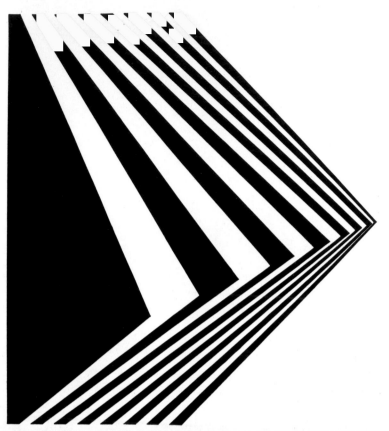

20 Study for **Off** 1963
Ink and pencil on paper,
17⅝ in. × 14¾ in.

21 Study for **Off** 1963
Ink, pencil, collage on
paper, 17⅝ in. × 16½ in.
The regular black and
white intervals at top
and base provide the
constant, which is
disrupted at an incline
by increasing and
decreasing intervals.
Both this and the
preceding study examine
these relationships.

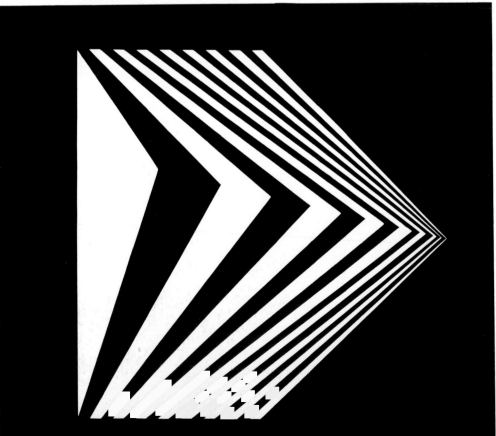

22 **Off** 1963
Emulsion on wood,
9½ in. × 6¾ in. (basic
width) and 11⅛ in.
(extended width)
The final image
resolved from studies
such as plates 20 and 21.
Despite its small size it
is related to *Continuum*
and anticipates plate 19.
See Anton Ehrenzweig
'The Pictorial Space of
Bridget Riley' *Art
International* February
1965.

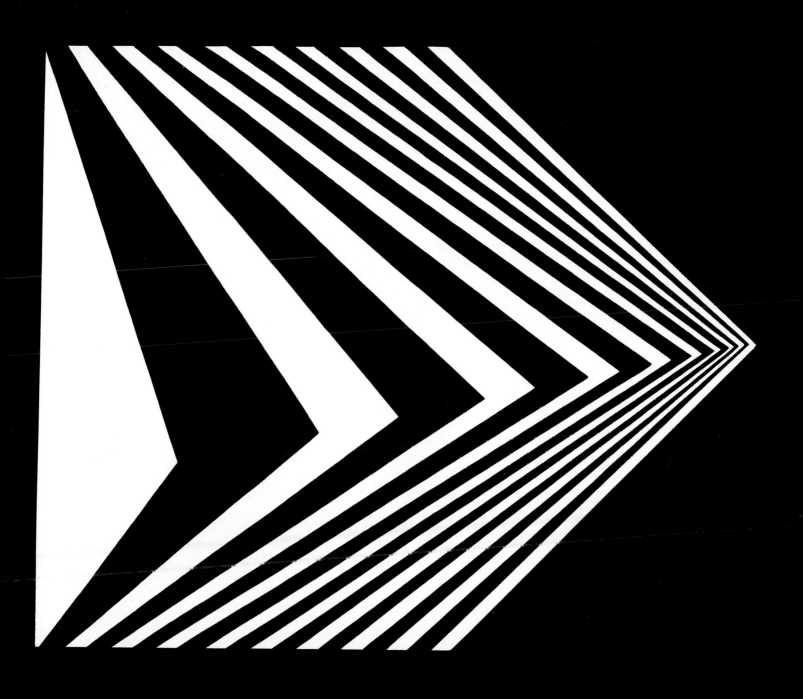

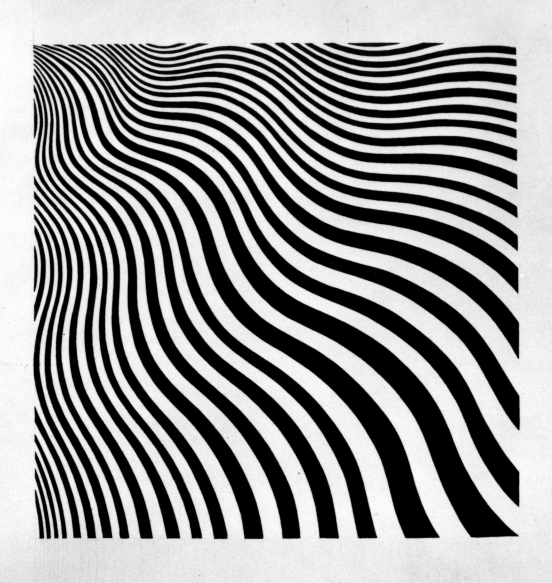

23 Study for **Intake** 1964
Ink, pencil, collage on paper, 20¼ in. × 18⅛ in.
One of many studies examining different relation-
ships between the units and the area perimeter. In
this drawing small, massed, slow curves are used.
Intake was the first painting for which full scale
cartoons were made.

24 **Intake** 1964
Emulsion on canvas, 70¼ in. × 70¼ in.
The diagonal curve moves from a slow to a quick
rhythm, simultaneously diminishing from an area to a
linear form.

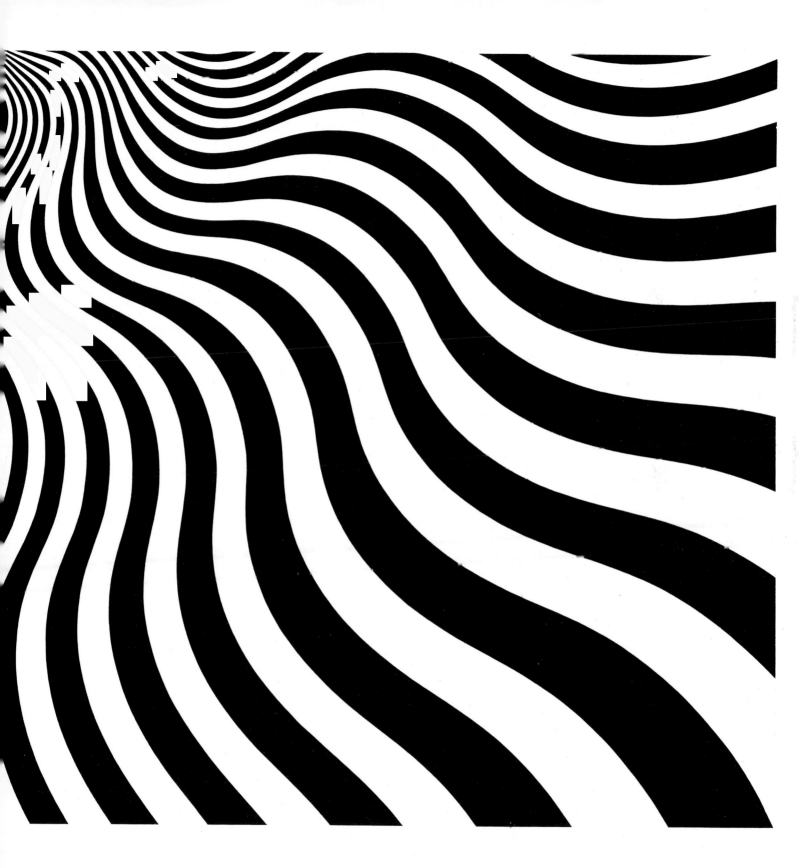

41

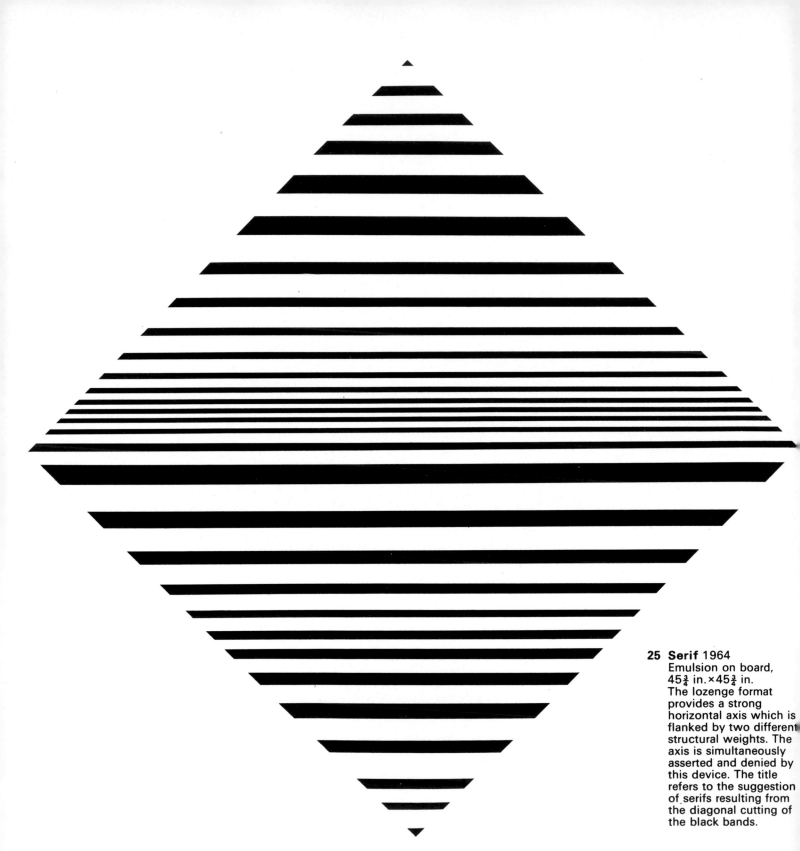

25 Serif 1964
Emulsion on board,
45¾ in.×45¾ in.
The lozenge format
provides a strong
horizontal axis which is
flanked by two different
structural weights. The
axis is simultaneously
asserted and denied by
this device. The title
refers to the suggestion
of serifs resulting from
the diagonal cutting of
the black bands.

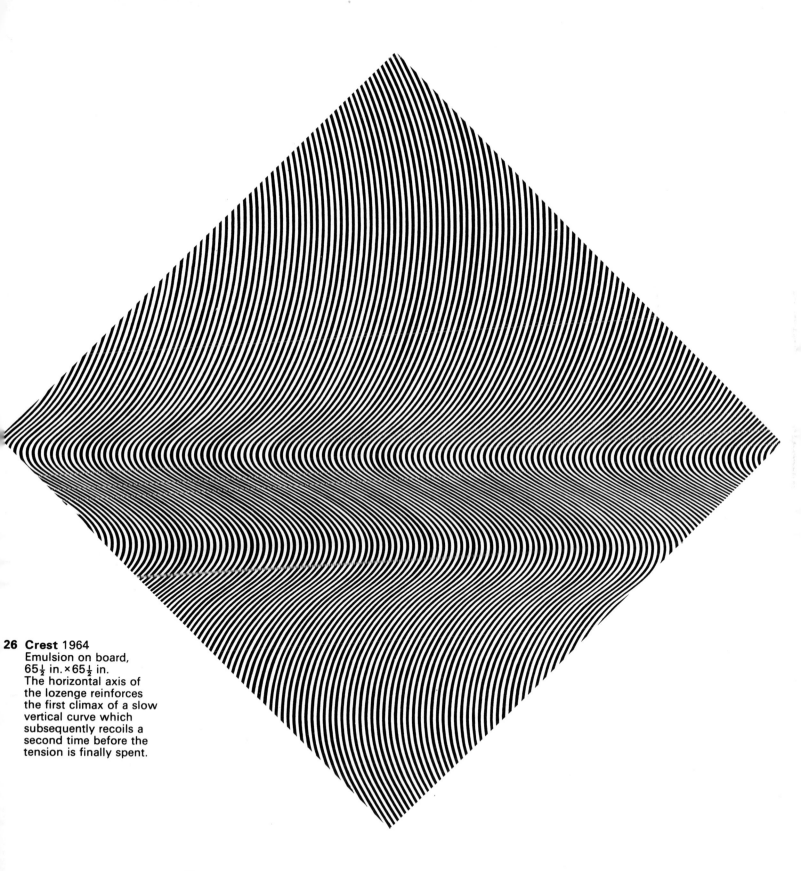

26 Crest 1964
Emulsion on board,
$65\frac{1}{2}$ in. × $65\frac{1}{2}$ in.
The horizontal axis of
the lozenge reinforces
the first climax of a slow
vertical curve which
subsequently recoils a
second time before the
tension is finally spent.

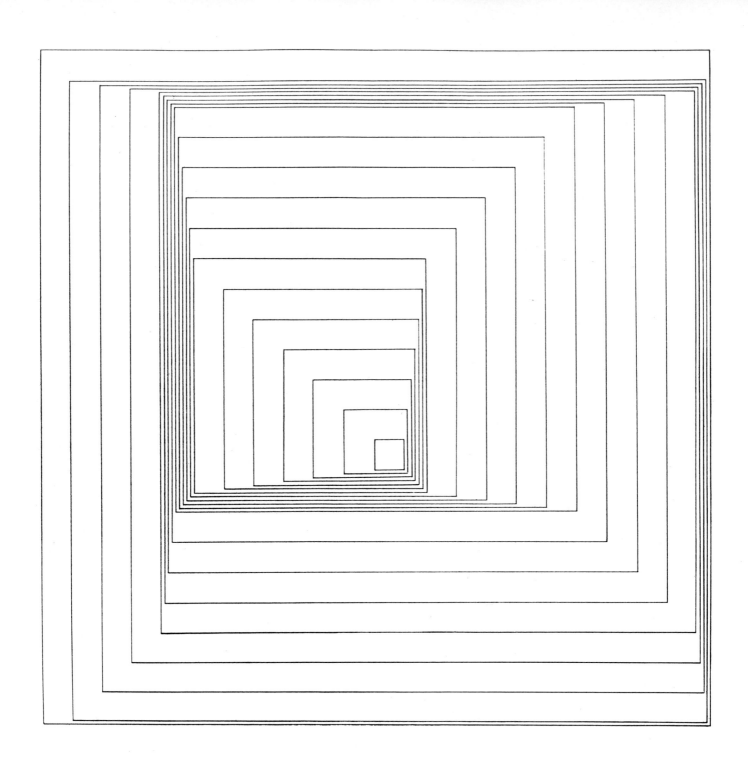

27 Untitled 1961
Tempera on hardboard, 26 in. × 26 in.
A counterpart to *Uneasy centre*.

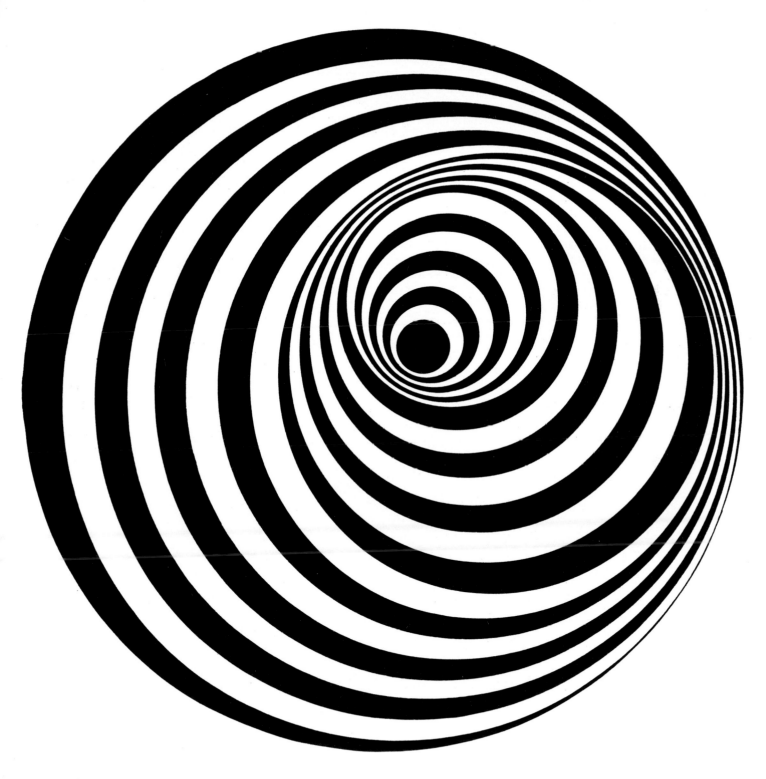

28 Uneasy centre 1963
Emulsion on wood, 15½ in. diameter
The individual circles contract successively in three different directions.

45

David Thompson *Bridget Riley* (catalogue introduction)
Venice Biennale, Venice, June 1968

One of the most distinctive characteristics of Bridget Riley's art is that it 'insists' with such concentration that it changes sensory response into something else. The experience which Riley offers 'is closely related to the expression of emotion or, more exactly, to the creation of visual analogues for sharply particularized states of mind. The very intensity of the assault which her painting makes on the eye drives it, as it were, past the point at which it is merely a matter of optical effect. It becomes acute physical sensation, apprehended kinesthetically as mental tension or mental release, anxiety or exhilaration, heightened self-awareness or heightened awareness of unfamiliar or even alien states of being.

Underlying such an effect is a basic, almost a traditional, assumption of what painting is all about — namely, perception as the medium through which these 'states of being' are directly experienced and expressed. And it is in the light of this assumption that Riley re-defines optical painting in her own terms. The novelty of the idiom becomes a novelty of emphasis, not of basic premises or of methods. Like so many of the most significant movements in modern art, optical painting has acquired its identity by focusing on one aesthetic function at a time. And in Riley's definition, it has focused on the process which makes it possible for painting to 'work' at all. Scientists call it psycho-physical response. Artists know it has the mysterious correspondence between forms, colours and emotion.

29 Disfigured circle 1963
Emulsion on board, $43\frac{1}{2}$ in. × $44\frac{1}{2}$ in.
A development from *Uneasy centre,* the circular image is divided yet remains connected. See Anton Ehrenzweig 'The Pictorial Space of Bridget Riley' *Art International* February 1965.

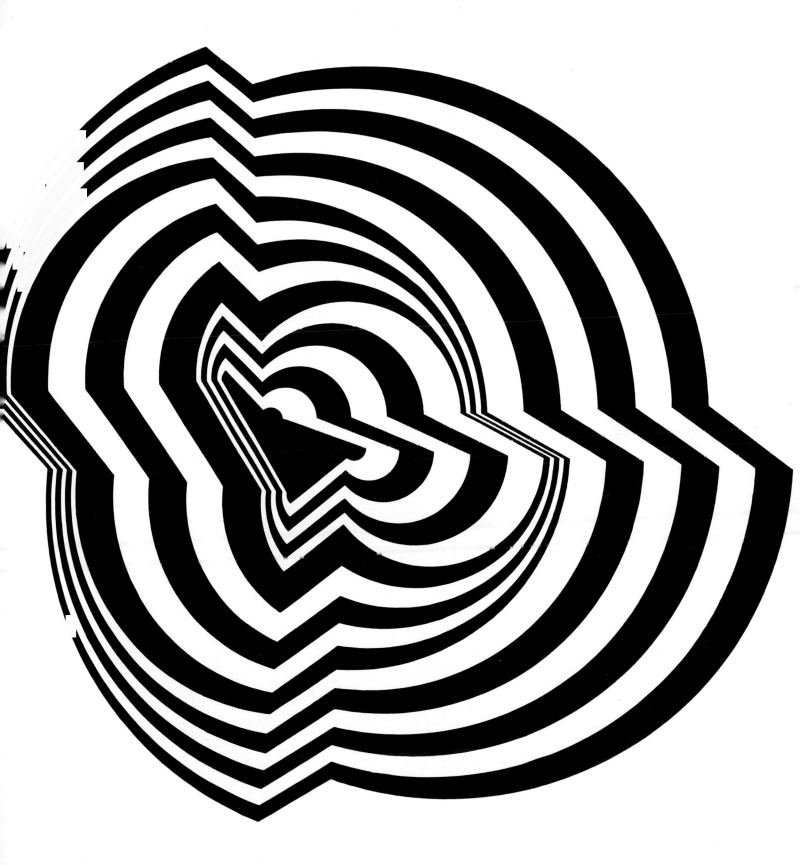

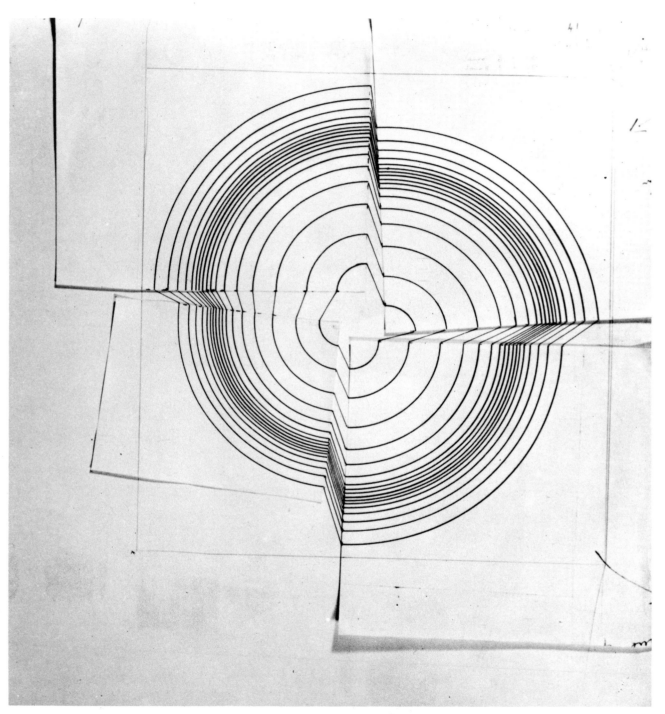

30 Study for **Broken circle,** 1963
Ink, pencil, collage on paper, 23½ in. × 21½ in. Gives
a clear indication of the working process.

31 Broken circle 1963
Emulsion on board, 50 in. × 50 in.
Belongs to the same group as *Disfigured circle*
although the linear image is light. The quarters are
identical and the circles arranged centrifugally so that
the contraction occurs at the same radial point.

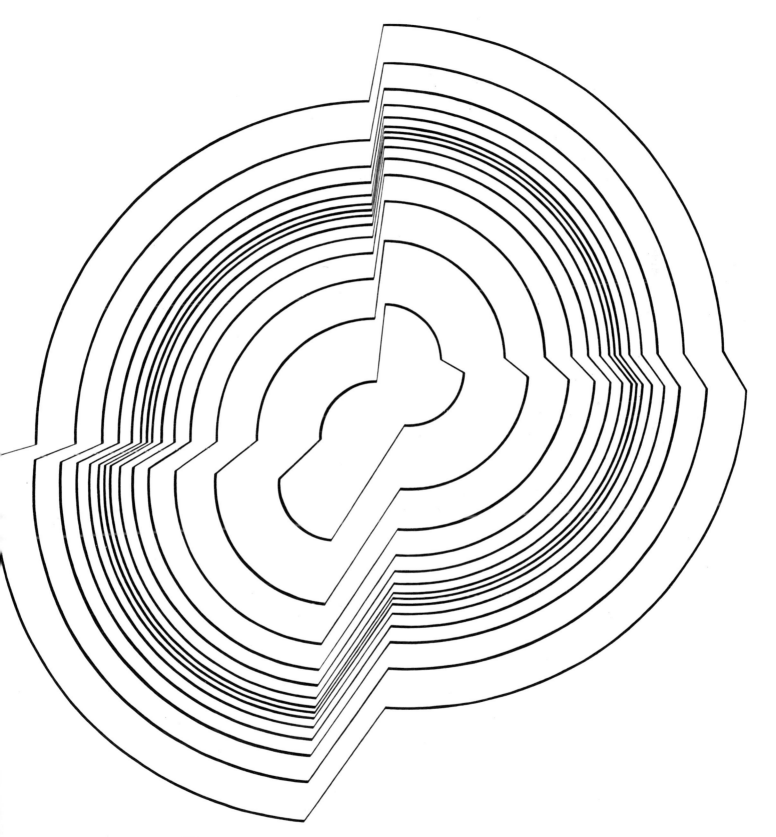

49

Anton Ehrenzweig *Bridget Riley* (catalogue introduction)
Gallery One, London 1963

Technically speaking, Bridget Riley minutely weighs the tension between her geo-
metrical, or near-geometrical units, so as to make them destroy each other. This see-saw
in two dimensions in turn produces contradictory shifts in space which, in a successful
work, must also cancel each other into a stable equilibrium. A perilous balance is
achieved as in a moving yet stable living organism. As we feel this balance, the whole
experience can turn inward to a new invigorating awareness of the structure of our
own body. When the moment of transformation arrives the single elements will cease
straining and pulling at each other. A new total vision comes through that is akin to a
true hallucination (it is misleading to speak of 'optical illusion' which lacks all important
feeling of revelation).

As an outer sign of the delicate balance achieved, strangely iridescent disembodied
colours, like St Elmo's fires, may begin to play around the centres of maximum tension.
This effect may be only incidental, but we must be grateful for the sensuous richness
it imparts to the total scene of transfiguration.

32 Blaze I 1962
Emulsion on board, 43 in.×43 in.
Complex in origin. At one stage the formal idea was in structured 'zig-zag' verticals, a
format which proved unsatisfactory but led to both the idea of this circular structure
(which may have been anticipated by *Circle with a loose centre*) and to a group of
shaped works, *Twist, Shuttle* and *Climax*. The relation of the circles to each other is
variable while the linear attachments on the perimeter of each remain constant, thus
expansion/contraction operates as a principle, while linear inversion produces a two-
track visual split: the resulting optical 'crackle' gives it its title. While we concentrate on
one set of linear movements, the other set is perceptibly reduced in power and tone;
surrendering to the total impact the white centre glows with a fierce intensity.

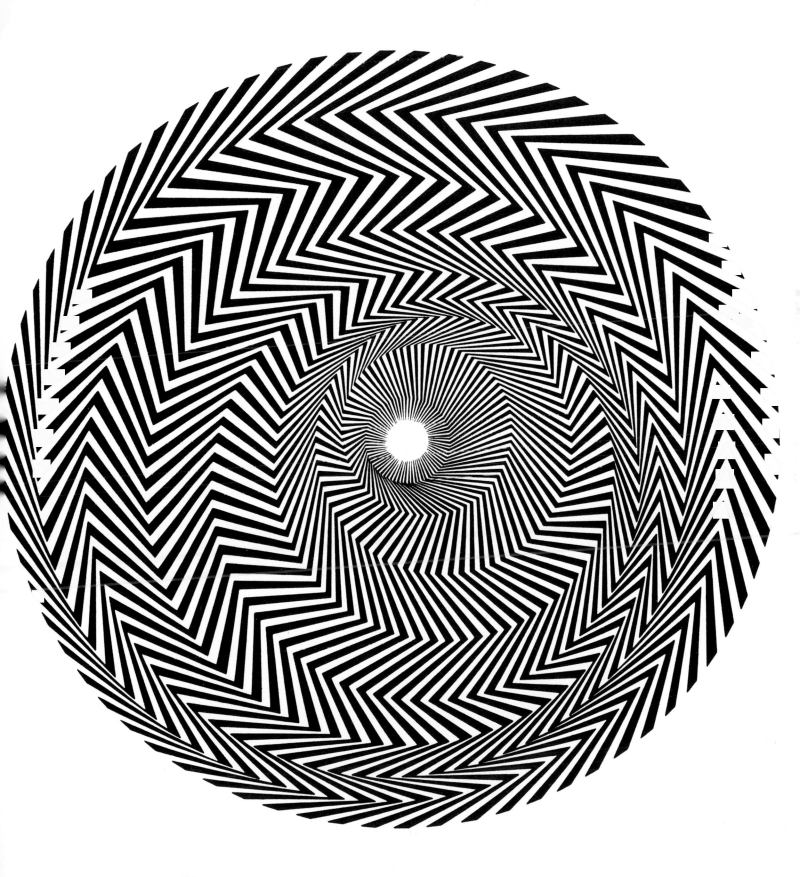

51

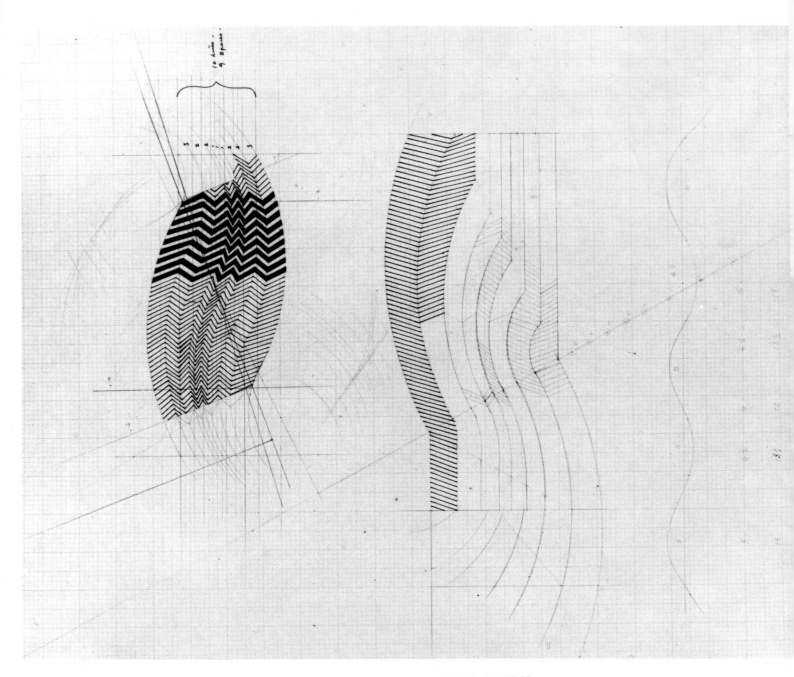

33 Untitled study 1963
Gouache and pencil on graph paper, 35 in. × 45 in.
Relates to *Twist, Shuttle* and *Climax,* revealing the
structural organization of curves, diagonals, and
accelerations and decelerations of tempi, which all
these paintings share.

34 Twist 1963
Emulsion on wood, 48 in. × 45¾ in.
A baroque convex/concave shaped area: the internal
curvilinear divisions are precipitated by two diagonals,
and by an extreme increase/decrease movement
across the top and base of the area respectively. The
regular black and white intervals of the chevron
maintain a constant. See Anton Ehrenzweig 'The
Pictorial Space of Bridget Riley' *Art International*
February 1965.

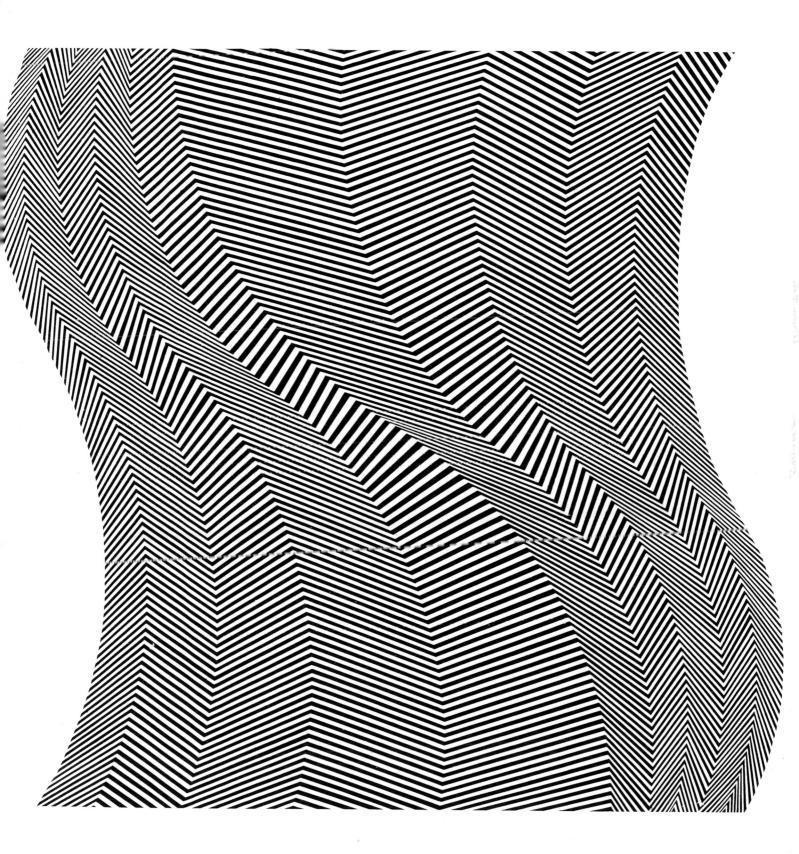

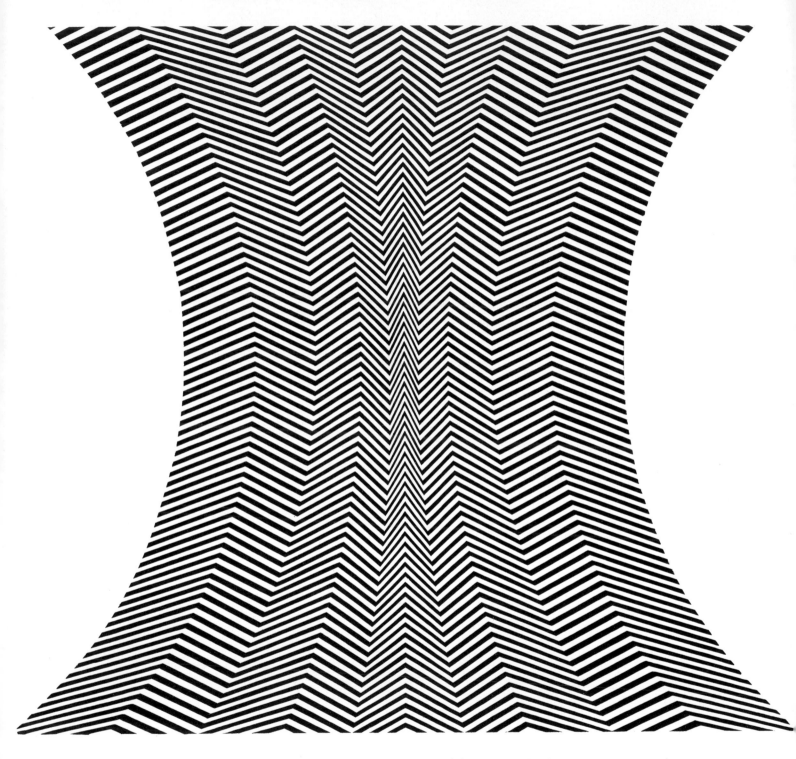

35 Climax 1963
Emulsion on wood, 36 in. × 39½ in.
The two concave sides straighten into a central
vertical as their intervals diminish. The measurement
of the area top is slightly narrower than the base to
balance visually, a refinement judged necessary after
the completion of *Twist* in which top and bottom
widths are identical.

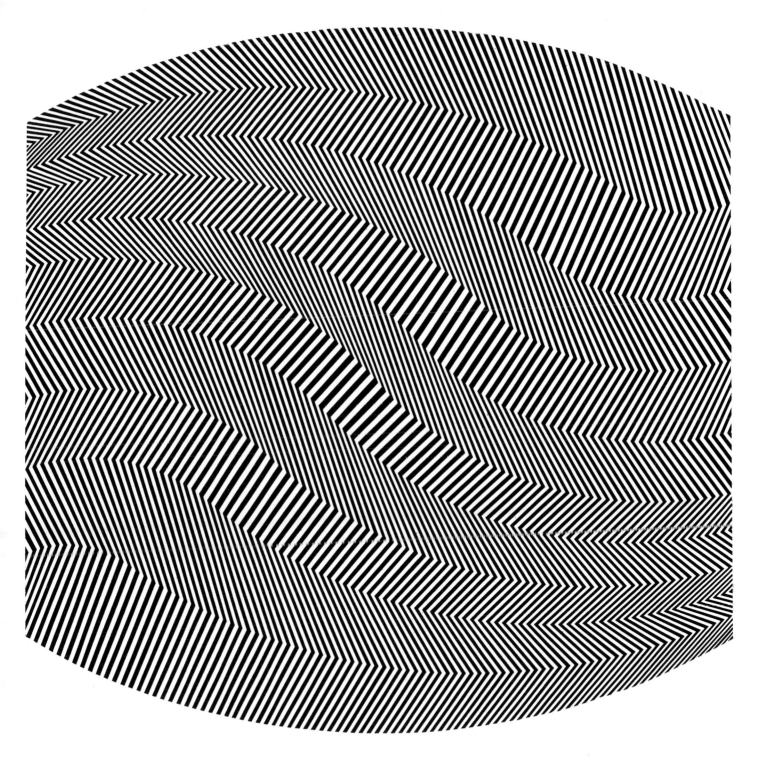

36 Shuttle I 1964
Emulsion on wood, 44 in.×44 in.
Has developed directly from *Twist* and leads on to
Climax. It is a single convex shaped area, while *Twist*
is both convex and concave, and *Climax* concave. A
diagonal (from top right to bottom left) provokes a
series of curved divisions, each either concave or
convex and subject to increase/decrease movements.
The two vertical sides of the area reveal these
clearly.

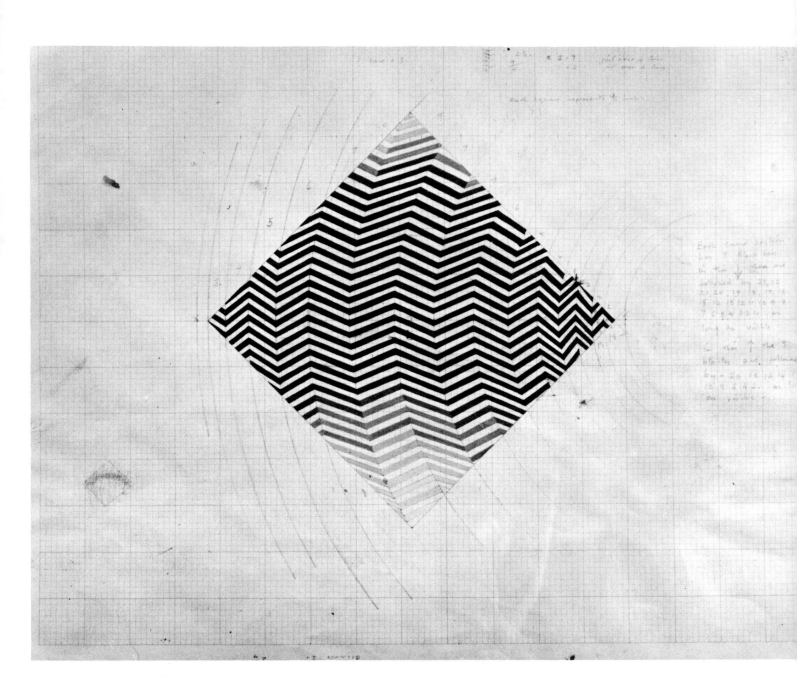

37 Study for **Cast** 1965
Gouache and pencil on paper, 13½ in.×17½ in.
The semi-circular divisions increase/decrease as they move across the area from right to
left. Greys bleach away the upper and lower tips of the lozenge format.

In conversation with Bridget Riley

M. DE S. On your return from Italy in the summer of 1960 and, prior to that, in your tremendous interest in Seurat, it seemed to me that things were already beginning to germinate relative to your subsequent way of working. Would you agree?

B.R. Well, one of the things I remember about working in Italy at that time was that I started to dismember, to dissect, the visual experience. I tried to analyse the colour of the situation, the form, the linear axis and the tone of the situation in quite consciously separate statements.

M. DE S. I well remember the separate colour units, almost like considerably enlarged passages from a neo-impressionist picture. If these pointilliste-like fragments could have been 'blown up' to an even larger scale they would have become entirely optically-operative works.

B.R. You are probably thinking of one of a pink landscape based on a view over a huge plain. Now, that was a powerful visual and emotional experience. The heat off that plain was quite incredible. It shattered any possibility of a topographical rendering of it. Because of the heat and the colour reverberations, to be faithful to that experience it was only possible to 'fire it off' again in colour relationships of optically vibrant units of colour. It wouldn't in fact have mattered if those had been black and black, or green and green – the facts of local colour were quite unimportant. The important thing was to get an equivalent sensation on the canvas.

M. DE S. Would you say that if there was any relationship between your thoughts at that time and the Futurists, whose work you had then recently seen in Milan, Boccioni for example, it was in the fact that he was attempting to work out a vocabulary of signs, a vocabulary of marks, a vocabulary of pictorially structural elements, which, brought together, would evoke certain states of feeling or states of mind – not descriptively in the usual illustrative manner but symbolically?

B.R. Yes, it is a question of substitution. As Cézanne said, painting is a parallel to Nature and the expressive quality comes through the structural means, through honouring both.

M. DE S. Would you say that it is this that links your work in the pictorial field with the idea of serialism in modern music – the attempt to control all the constituent parts of the compositional process by employing extremely disciplined means in a fully free and expressive way?

B.R. Yes, I think serialism is a very good parallel because in the beginning phases when I am working on an idea I might for example choose a unit, say an oval, and I 'pace' this unit, as I call it. I put it through its paces, I push it to the fullest extent where it loses, or almost loses, its ovalness, its oval characteristics. I see, so to speak, what an oval will do.

M. DE S. Do you do this in your mind or do you actually materialise it on paper?

B.R. I do it physically because there is no possible way of doing this purely conceptually.

57

M. DE S. No, I appreciate this, but presumably you could have a hunch about the thing, a strong intuition that the particular unit is capable of considerable exploration?

B.R. Exactly. I might find for instance that a certain triangle is much more restrictive than I had thought. I find that the most restrictive form of all is a circle.

M. DE S. Now, is it out of the nature of this early 'putting the thing through its paces' that you begin to see the possibility of expressing a feeling or idea, or is the idea or the feeling a very late outcome of the work?

B.R. It comes very early. In fact, having now some five years experience behind me, I am familiar with some of the things some forms will do in some situations, how they might behave, so that my hunch is already reinforced by experience. I don't waste much time on red herrings, on irrelevances. Nevertheless I never jump to conclusions, I never presume to know. I go through phase by phase each time because there may be something different in the demands I am making on this form which may miraculously throw up new possibilities.

M. DE S. So, in fact, if you could describe the phases through which an idea moves it might be something like this – initially you have a sort of 'hunch' about a configuration and the unit involved. Then you put the unit, or structural elements that have occurred to you, through a whole series of different situational responses, provoking them, so to speak, to vibrate against each other in several ways, in a set of structural variations. This goes down in a number of small physical notations and drawings. Often I suppose it is only necessary for you to work out a quite small fragment to see the potentialities in it – you don't need to work out the whole thing each time?

B.R. Oh no. But of course absolute precision is needed in even the merest fragment,

M. DE S. These are the earlier ideas or studies. Now, is it from this experience and these initial studies that you elicit the idea of a big final painting? Clearly this must throw up quite a number of possibilities and alternatives?

B.R. Yes it does. I usually find myself faced with a number of structural choices and at this point I start to think in levels, so to speak. If I have something moving in one direction on one level, and another direction on another level, counteractions are taking place. Sometimes a situation may carry these statements and anti-statements two or three deep, and sometimes it will become top-heavy and the structure will collapse, simply because there isn't enough emphasis given to three or four major relationships, and by the time I get to six inter-operative factors I've arrived at a jumble, arrived at in-coherence because it has become too elaborate. I believe more and more that we are at a point now where the work must be additive, one simply cannot go on striking one note *ad infinitum*.

M. DE S. But to go back to what we were saying about the early phases of a work, what you appear to be doing in the early stages is harnessing certain potential forces and playing them against each other to generate new situations, or qualities, or energies.

B.R. Exactly, it's the sort of space between these energies that takes on the character of, as it were, electrically charged fields – it's as though the arrows instead of doing that, do this.

M. DE S. I suppose that in the early phases of the planning of a painting the bringing together

of quite powerful forces may sometimes spark off, or bring into being, something quite gentle. For example *Breathe* (p. 109) is really a slow painting isn't it, and yet the elements that are used to bring it about are quite powerful.

B.R. I think that this is something to do partly with scale of area, but more essentially with scale of unit.

M. DE S. Now, this question of scale – you place it very high in importance?

B.R. Yes, certainly. To take an example, when I had got *Black to white discs* (see p. 24) to a small scale it was a slow painting and when it became larger it became slower still. When its character was revealed in this slowness I realized that by increasing the scale a more positive statement of slowness would be made.

M. DE S. So in point of fact these energies you have been talking about are very dependent on the actual scale; sometimes at a small scale the energies will presumably work at a faster speed, and *vice versa*?

B.R. Yes, sometimes, but one cannot generalize. It is not so much the scale of the area that one can say this about, but rather the scale of the unit.

M. DE S. Yes, the scale of the unit and, from that, the degree of intensity with which the unit will inter-operate.

B.R. Exactly, and this is where you have to deal with frequency, visual frequency.

M. DE S. Or, in other words, a sort of optical bounce. You can, as it were, bounce the structure very high or just off the ground. Now, is it at this point that the clarification of a title takes place, what the painting is about or what sort of mood it is going to represent?

B.R. I think the choice of title, or the clarification of the character of the painting has been becoming clearer and clearer gradually throughout the whole period I have been working, not suddenly at any particular stage of the work. In fact, one of the ways that I can detect red herrings, or things that cloud the issue, is when the picture radically changes direction halfway through. This is something that can happen and which I don't trust.

M. DE S. This element of consistency therefore means quite clearly that you have a pretty clear concept of a goal, somewhere you hope to get to with the painting.

B.R. Yes, I have. I think it is very much like playing with a hoop as a child. You play with a hoop and it goes along and you run with it and the hoop keeps going, but if the hoop bounces on a stone you don't exactly know where you are going next . . . Of course, when it hits a wall you know perfectly well that that's not right, but in rather less final situations I suppose this is where the intuitive hunch comes in.

M. DE S. You know when the thing begins to move in diametrical opposition to your thoughts and feelings about it in the early stages?

B.R. I feel it has something to do with allowing the energies room to breathe, as it were. If they are handled freely those energies will come through full-charted. I never feel that I confer any energy on anything, it's all there to be unlocked and articulated.

M. DE S. So in a way it's on this level that one could say that your work is still to some extent rooted in the concept of natural forces, physical forces?

B.R. Yes, physical forces, and unless thought becomes physical feeling it doesn't really work. About a year ago I had probably overworked and I was forcing myself to continue

and I started on a series of ideas. They had an impeccable logic that was most exciting, an exhilarating mathematical concept. It was one of the few occasions when I didn't 'pace' anything. I didn't even select a unit – a situation almost unique in my work. I then tried to find the actual physical situation in which this perfect thing that I had built up intellectually would operate . . . and I could not find one, I just could not make it visible. In point of fact I had, finally, to assume that it had never been truly visual in my terms at all.

M. DE S. In fact you are building not just in 'good ideas' but in forms, in forces, in units, in elements, in energies?

B.R. Each of these words can represent higher electronics or something else. The important thing is that I am using them *visually*, as they arise visually. It is from the visual externalization of something that the dialogue starts between the artist and his medium.

M. DE S. There is a story about Degas and Mallarmé that seems relevant here. Apparently Degas tried hard to write poetry for a long time and one day said to Mallarmé 'You know I cannot understand why I am not able to write good poetry, I have the most marvellous ideas' and Mallarmé is reputed to have said 'Poetry isn't made with ideas but with words'. Something similar holds good for you too; unless you can somehow bring this thinking to terms with your medium and actually conceive in the physical stuff, the thinking you do is not relevant. It just doesn't tie up.

B.R. Yes, that's true, but I do also agree with Boccioni that even smells, noise and so on, have a visual equivalent and can be presented through a sort of vocabulary of signs. His use of the word 'ambience' to describe this sort of inclusiveness of experience seems so right.

M. DE S. Your works certainly represent feelings and personal experience but I would not have said that you were in any real sense an expressionist painter. Your pictures contain reference to personal feeling and experience in a somewhat elliptical fashion, not at all in a directly impassioned way.

B.R. It is a question of the dialogue between the medium and myself. The medium is every bit as strong as any human psyche, or will, or brain – one is well matched, if not sometimes out-matched, in this dialogue.

M. DE S. To what extent are you disposed to think of your work in terms similar to scientific experiment?

B.R. I think that experiment goes on in the drawing and preparatory phases, and also between paintings. But as I have more and more paintings behind me I find that I experiment increasingly slowly because, whereas at the beginning one can make vast strides in a few basic things, as one goes on one finds that those discoveries or experiences are not refuted, they are still operating and one is forced to experiment in an ever-tightening field.

M. DE S. But the work itself, the finalized products, to what extent do these seem to you to be part of an experimental situation?

B.R. The finalized work is not.

M. DE S. I rather expected you to say that, but I think this is something that is subject to much misunderstanding. People frequently speak about optical painting as though it were a

rather primitive experimental stage of something that may ultimately become art, rather than its being an art of full achievement.

B.R. I think that one of the most interesting things about Biederman's book is simply its title, it's on the nail: '*Art as the evolution of visual knowledge*'. I feel sometimes a slight awkwardness in my attitude to the term 'Op Art' because it smacks of a sort of gimmicky selling slogan of purely temporary significance.

M. DE S. Nothing could be further from the truth. It has had a long build-up from the past and one feels quite sure that it is going to have a continued development in the future.

B.R. I think this is undeniable. I am absolutely certain that optical painting, as we call it now, has added something to the language of formal art, to plastic understanding, which cannot be ignored or eradicated. In the same sense that Cubism added something to a concept of space which, once having been assimilated, could not subsequently be discounted. You have to come to terms with its presence.

M. DE S. What are your views on the attitude of artists, like the Groupe de Recherche d'Art Visuel, who see the whole business of art today as being a continual process of research?

B.R. It seems to me that the idea of research in painting is a deliberate effort to create a link with science and has also something to do with the desire to move the artist firmly but determinedly from a peripheral position socially, into a central position where he can hold his head high in a world of computers and that sort of thing.

M. DE S. This mention of computers brings us to the question of de-personalization in the whole procedure of painting. There have been attempts to present this sort of painting as a serious effort to remove the evidence of personal involvement in order to allow the works to stand as things in their own right, purely as phenomena. What is your feeling about this?

B.R. Superficially it sounds like a rather glib comment by the Philistine public, but I think that there are quite a few artists who have promoted this idea. To me there is one area in which it is quite untenable – the area of decision. If you refuse to make use of your faculty for deciding and for selecting you have to programme everything through the entire field. Now this, although it might seem to be quicker, would in fact be very much slower, and in addition it is a denial of man's intelligence and perception. Sometimes people have said to me 'Why don't you use photography or silk-screen?' but they fail to realize that in many of my paintings the units are all fractionally different.

M. DE S. In many respects the way you work would seem to be through a process of objectivity rather than subjectivity, you are watching what happens on the canvas rather than what is going on inside you.

B.R. No matter what I do it will be subjective, and so to develop as much objectivity as I can, is simply counter-balancing this inevitable presence of myself in the work. De-personalization is, I think, a bogus hue and cry. When I was teaching children in classes of twenty and thirty I found that however much one set them a common problem, each child provided a different solution. I never found a uniformity of solution however strictly the problem was proposed. So I feel that if a group of optical artists were commissioned to make a series of paintings using triangles, every one of these works would be very different because the decisions would have been taken by very different people. It's the decisions that are the important factors.

M. DE S. This is the creative element, this is really where the whole art lies.

B.R. Yes, but you must have something to decide about, and this is your medium through which ideas have to become specific art forms.

M. DE S. To return to the use of the term 'Op Art', have you ever thought of an alternative? Is there any other term that might describe it more adequately?

B.R. I think Seitz's term 'Perceptual Abstraction' was quite a good one but even that was limited. In its crude way I think the term 'Op Art' is perhaps right, but it's the contemporary connotations that I resent. But in the sense that it is an approximation like the term 'Constructivism' I think it's right.

M. DE S. You have said in an earlier interview 'I think my conception of space is more American than English' and I am wondering whether you have anything further to say on this subject of conceiving space?

B.R. I certainly think of American space as being open space, shallow space, a multi-focal space, as for example in Pollock, and I feel more in sympathy with this than with centralized European space, the focally centred situation of the European tradition. Nevertheless, I use occasionally this concept of space which in a sense has two counter-point centres. But on the whole I tend to work with open area space – and when I refer to this as American space we must not forget that it had its origins in Mondrian. It demands a shallow push-pull situation and a fluctuating surface. Now sometimes I am able to bring this about simply by two-dimensional interactions, but sometimes it operates not unlike the action of a whip that you can crack. It has an even movement which sometimes may go too far and actually break the space, and you move into a depth of space which people read as three-dimensional space by association with the Renaissance. I try always to eradicate it but not at the risk of destroying the original impulse. This is one of my biggest difficulties.

M. DE S. But then you not only work with these units you were speaking of earlier, you also use changes in speed don't you? Are these represented in your mind by proportional variation, or arithmetic series? For example if you say 'Seven, three, one', that might represent a sort of sequence which controls an optical speed.

B.R. A lot of my notations for recent paintings are written down in this way, and one might think that I had selected seven and three, for example, because of some perfect relationship independent of vision, but I am in fact experimenting in tempi. For example, this slow movement turns out to be seven which looks right with three, but if I try six and five it may not be discernibly different, but in the case of eight with two the jump is too big visually. By the time I have reached the point of writing down seven and three, I have drawings pinned up around the studio with other pairs of relationships stated from which I have chosen seven and three as right for my purpose. But there are two types of tempo. There is the overall tempo of the picture and there are the different rates of movement, the separate tempi, of the units within the work. I think the first time that I became conscious of this was in starting to use grey. I wondered why I was using grey; it is mid-way between black and white and clearly this relationship is encompassed in the three stages: white, mid-grey, black. But you can have it in five beats, seven beats, twenty-four and so on, and all the time you are in fact changing the tempo. I became very interested in this question of visual time.

I worked through a whole series of paintings using this concept, as you can see in *Where, Remember, Loss, Hesitate* and others. This has led to my trying to pitch this type of tempo against a structural tempo with axial movement.

M. DE S. This tempo could operate, presumably does operate, in the placing of the actual units relative to one another in the visual field, so that this is in effect an absolutely fundamental issue?

B.R. Yes, it is. One of the most difficult problems I have been involved with recently is that of warm and cold greys. I thought that if I split the grey sequence in two, it might give rise to additional energies. But two is a difficult situation, it can be like a full stop. I found that it only fully justifies itself when one factor is constant.

M. DE S. Isn't this really true of all virtual dynamism or perceptual dynamism. Isn't it dependent on there being somewhere a constant against which other things will appear to move or vary?

B.R. This, I now realize, was a known factor but when I personally first discovered this I was tremendously excited; the interdependence of static and active. And this is interesting in relation to our earlier discussion about experiment. When you are using a basic truth, a phenomenal fact, you can't put it aside and supplant it with another – it *is* a fact. It is rather like gravity, once you have realized the fact of gravity, it doesn't change and from then on you have to reckon with gravity.

M. DE S. To the extent that you are building through a sequence of phases, so, in the course of time, the totality of that experience in terms of experiment is at your disposal, always.

B.R. It sometimes amazes me when people say 'How do you work?' because in fact it is all in the painting, it is absolutely self-evident. If someone is interested enough to look at the painting he will find out all there is to know. Nothing is hidden, other than a few structural lines maybe which I do not want to be visible. To leave traces of tick-tackery around is a form of inverted craft snobbery, but eliminating the constructional lines doesn't obscure in any way the record of the decisions in my paintings. For instance, in some paintings where there is a greater tension at the base it should be obvious to any spectator that the curve, if I happen to be using that unit, has moved and changed in a certain way, and this gives rise to the increased tension.

M. DE S. The mystery of creation for you then is not so much in how you work, or the phases in the procedure, but in what is evoked out of the inter-play of those tight, straightforward, physical elements that anyone can observe in your paintings. You yourself must experience a revelatory excitement in the emergence of this intense dynamism, the by-product as it were of your total frankness in the use of all that lies on the canvas.

B.R. It is also the measure of the vitality of the medium – the answering back – in the creative dialogue.

8 January 1967

63

38 Study 1965
Pencil on graph paper, 28 in. × 40 $\frac{5}{16}$ in.
Example of a unit being put through its paces. Starting
with an inverted triangle within a square, point-
movement is explored; then the sequential change of
the unit through linear modification; serialization is
represented in the structured cluster of letters and
figures. In the lower half of the drawing possible
sequences are given linear structuring and the eye can
begin to estimate inherent tension/disruption
energies. On the base line there are examples of the
planning of point-movement, horizontally, diagonally,
centrally and half-diagonally. Despite the date, this
drawing clearly comes from the same level of creative
thinking that gave rise to *Straight curve* and *Tremor*.

39 Tremor 1962
Emulsion on board, 48 in. × 48 in.
A 'buried' image, related to *Hidden squares* and
Opening: the basic triangular unit develops only two
other alternative states by the substitution of a convex
or concave curve for a straight side. See Anton
Ehrenzweig 'The Pictorial Space of Bridget Riley'
Art International February 1965.

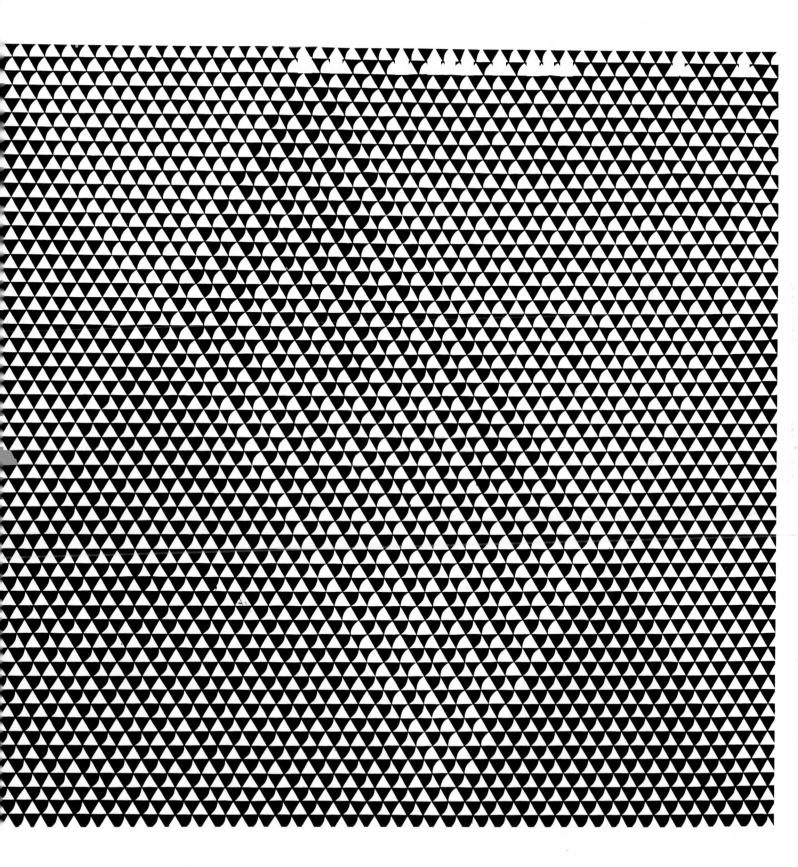

65

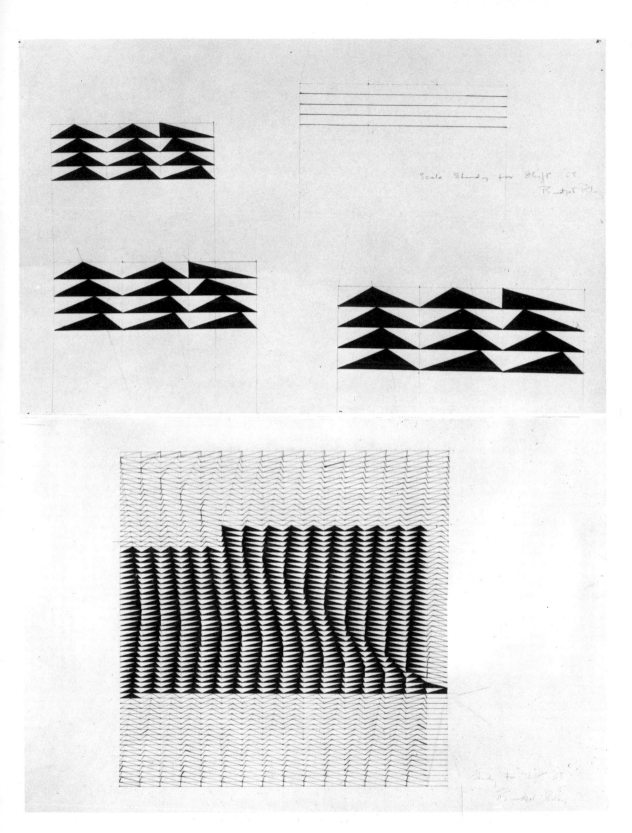

40 Scale study for **Shift** 1963
Ink and pencil on paper,
15 ⅛ in. × 22 1/16 in.
The triangle unit is
represented in three
different sizes, and the
scale best suited to
operate effectively,
relative to the total field,
is selected. The move-
ment of the apex of the
unit within the vertical/
horizontal grid is clearly
shown.

41 Study for **Shift** 1963
Ink and pencil on paper,
22 1/16 in. × 29 5/16 in.
The structured field is
completely indicated in
linear form and a central
area worked with solid
black to test the energy
strengths. The apex of
the triangular unit is the
variable point moving
horizontally from right to
left and back in the
vertical/horizontal
structured field which
remains constant.

42 Shift 1963
Emulsion on canvas,
30 in. × 30 in.
Movement of inverted
triangles in which the
two points of the tri-
angle unit remain con-
stant while the third
moves in a serialized
fashion from left to right
and back again: the
rhythmic changes create
powerful lateral and
diagonal thrusts. This
again is a work of
seminal importance being
the first in which point-
movement was used.

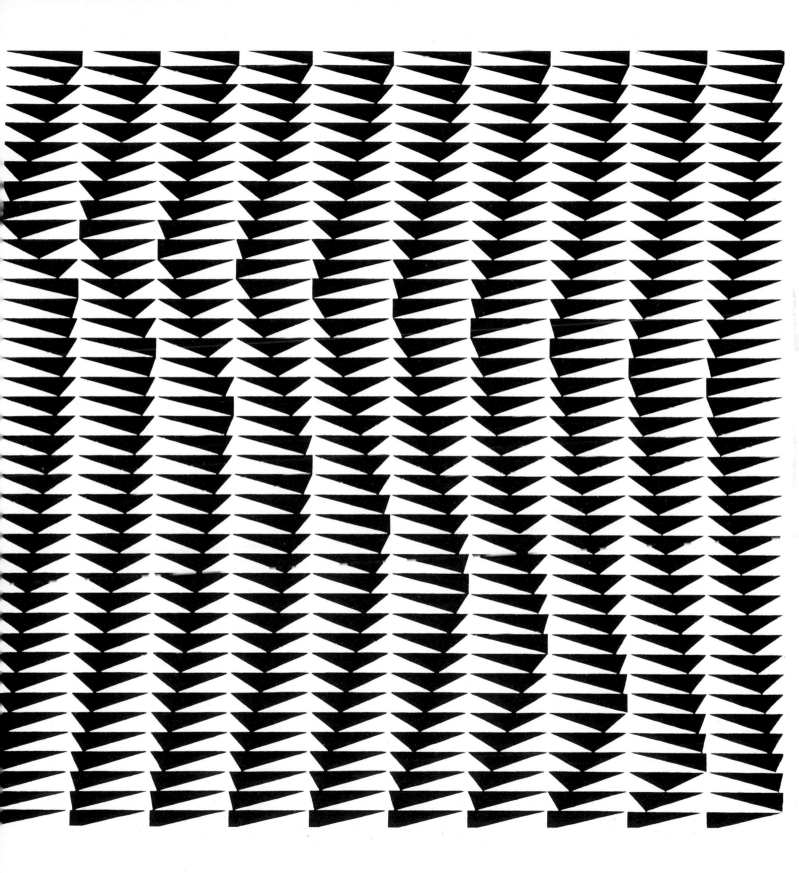

John Russell *Sunday Times* September 1963

A Riley is about the changes — progressive, sometimes abrupt, sometimes apparently disastrous — that can take place in a given situation. That situation is presented in the simplest possible terms. At its point of departure it may well have looked like a Palladian ground-plan, or a diagram in which lines of force are made visible, or the prototype of a new kind of powered screw. The changes to which that situation is subject are presented in terms of colour-contrasts confined to black and white; shifting, accclerating and decelerating eye-rhythms; linear movements that confound expectation; and unexpected pulls and thrusts that bring the whole structure to the point, it seems, of breakdown.

The paintings could be read as studies in dislocation; but their final statement is on the side of recovery and integration, and their effect for that reason is one of an intense and hard-won exhilaration.

To see these pictures in terms of optical effects, as some people have done, is like seeing the storm scene in *Lear* in terms of mean rainfall. Optical effects play a part in them as they do in the work of Vasarely: but in a Vasarely the optical effects are subordinated to a generally expansive, relaxed, caressing, large-hearted view of the world; in a Riley they ram home to the observer the fact that he is in dangerous country. There are no points of rest or vantage in a Riley: hazard is everywhere.

43 Fission 1962-3
Tempera on board, 34¼ in.×35 in.
Constructed on the same principles as *Movement in squares* but with a circular spot replacing the square as the unit. In addition the speeds of movement are changed horizontally to create the fission of the title.

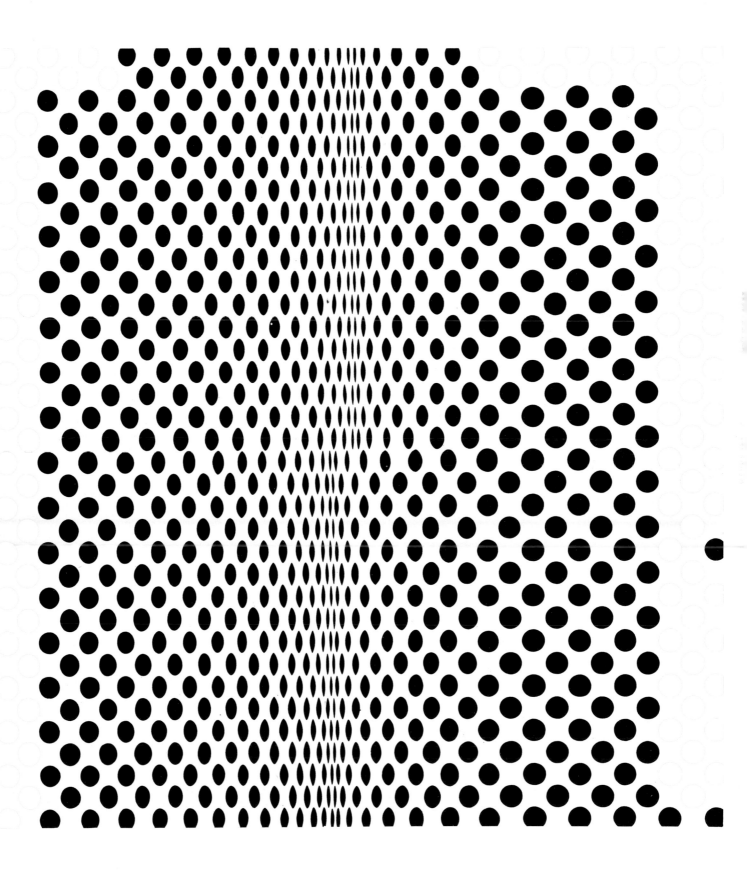

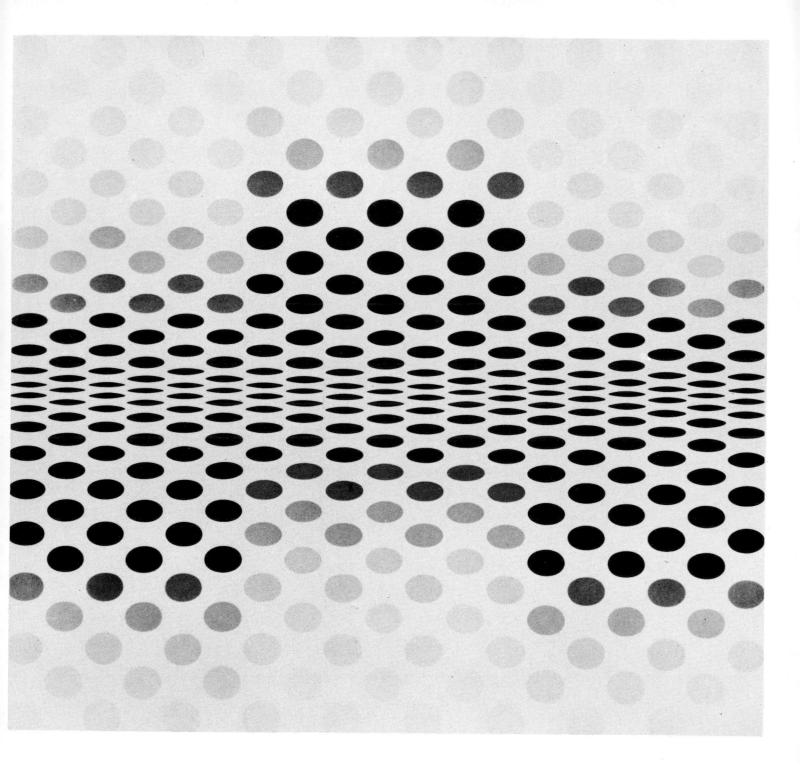

44 Where 1964
Emulsion on board, 42 in. × 44½ in.
A constant horizontal structure displaced vertically by
tonal sequences moving at different tempi.

45 Pause 1964
Emulsion on board, 44 in. × 42 in.
Related to *Fission* but here the constant vertical
structure with its critical phase of gradually com-
pressed circles is disrupted and virtually obliterated by
a curving tonal sequence.

70

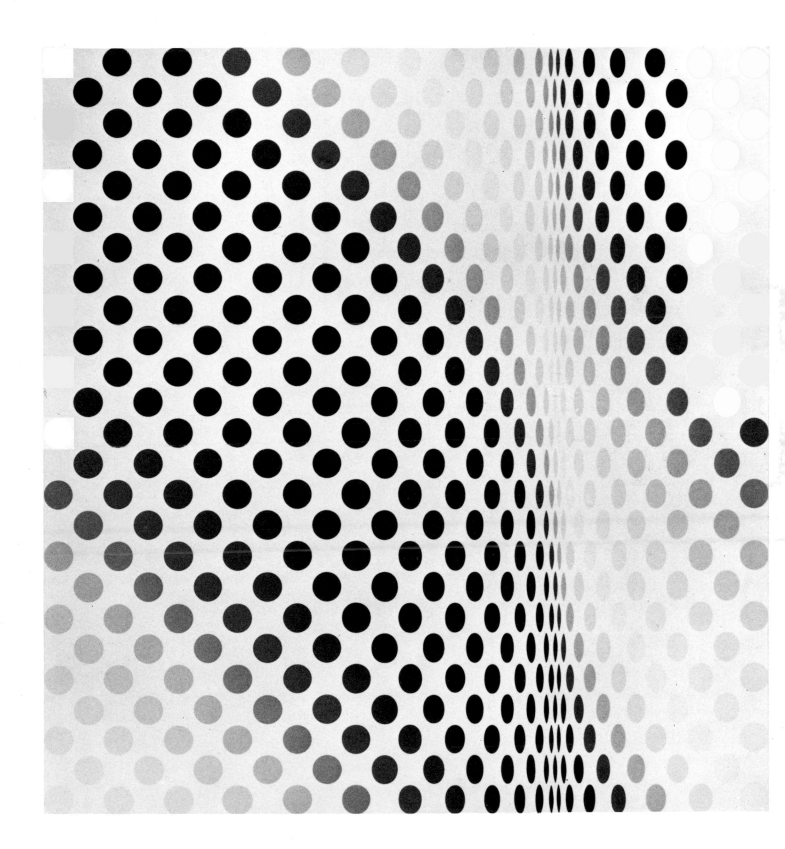

71

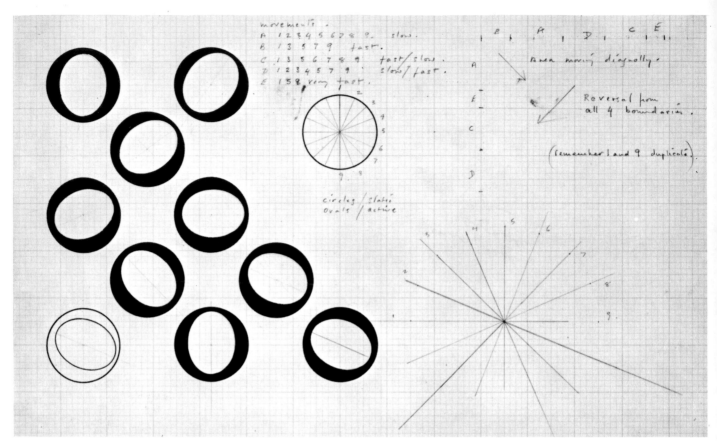

46 **Untitled study related to Disturbance** 1964
Pencil and gouache on graph paper, $9\frac{1}{2}$ in.×$15\frac{1}{2}$ in.
The axial changes in the unit provide the variant in an
otherwise constant situation.

47 **Fragments no 4** 1965
Plexiglass print, 28 in. × 27 in.
Belongs to the same group as *Disturbance, Static,
Deny* and the *Nineteen greys* silkscreen folio. The
inner oval remains a constant vertical while the outer
oval moves slowly but subtly.

48 **Disturbance** 1964
Emulsion on canvas, 68 in.×68 in.
A constant vertical/horizontal field-structuring
affected by the unit, an O-shape, is alternated with a
blank space, both in its vertical and in its horizontal
positioning. In addition, as the basic unit moves it
changes its axial direction according to serial
principles. This results in opposing diagonal move-
ments appearing when the total structure is scanned,
with consequent tendencies towards attempted, and
continuously frustrated, *Gestalt* grouping of units in
containing diamond shapes.

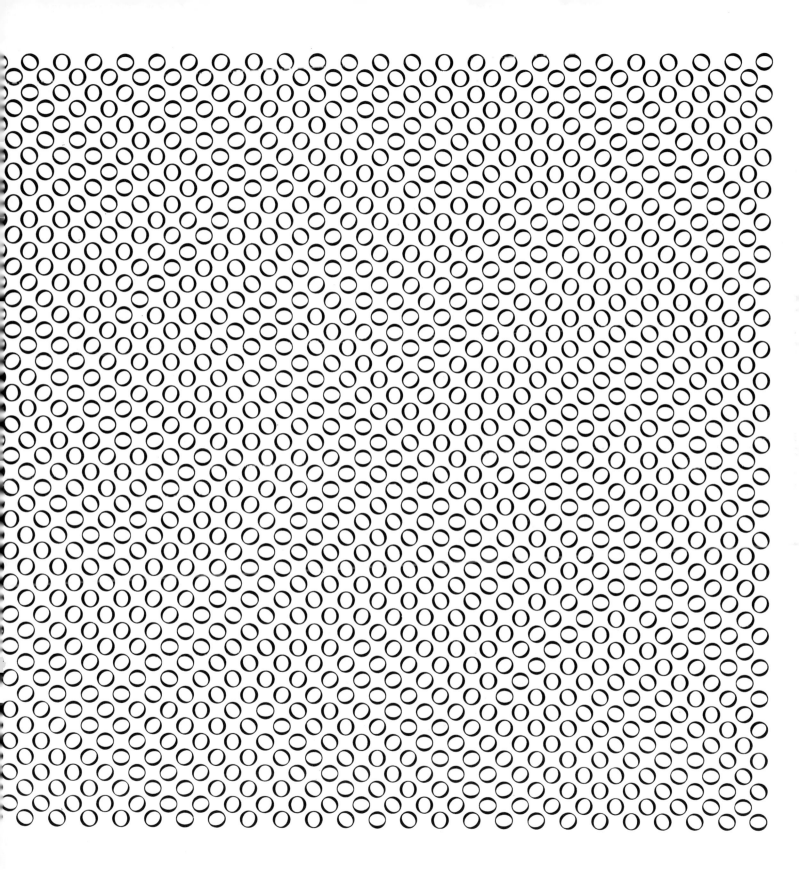

49 Study for **Static II** 1966
Biro on tracing paper.
The angle movements shown by the short lines
will be articulated by the long axis of an oval.
The angle movement is emphatic in order to
compensate for dilution by the wide grid spacing
and the small size of the oval unit.

50 Static I 1966
Emulsion on canvas, 90 in. × 90 in.
The *Static* series use both square and diamond
grid structures. This was further developed in the
Deny canvases and the *Nineteen greys* folio of
prints. See page 63 for further discussion of the
painting.

74

'Bridget Riley interviewed by David Sylvester'
Studio International March 1967

D.S. What of *Deny?* It seems to me that two optical effects happen there. One is that the little ovals, when seen from a certain distance, seem like pieces of reflecting steel cut out and stuck to the painting, shiny and light-catching. Was that part of the intention?

B.R. No, it wasn't.

D.S. Secondly, there's a curious effect when you stand close to the painting of a thick grey mist or smoke between you and the painting. Was that part of the intention?

B.R. Yes . . . obscuring, negating it.

D.S. What else was in your intention?

B.R. To oppose a structural movement with a tonal movement, to release increased colour through reducing the tonal contrast. In the colour relationship of the darkest oval with the ground, the change of colour is far more pronounced than it is between the lightest oval and the ground, where you get a tonal contrast — almost a black and white relationship — happening instead, which knocks the colour down.

51 Deny II 1967
 Emulsion on canvas, $85\frac{1}{2}$ in. × $85\frac{1}{2}$ in.
 Warm pitched against cold; one remaining constant over the whole field, the other moving fast/slow in tonal sequence influenced by a falling diagonal movement from left to right and top to bottom, which rises again diagonally in reverse fashion. The oval units, positioned by relation to a grid of constant equi-distanced points, are subjected to tonal change and individual internal axial change.

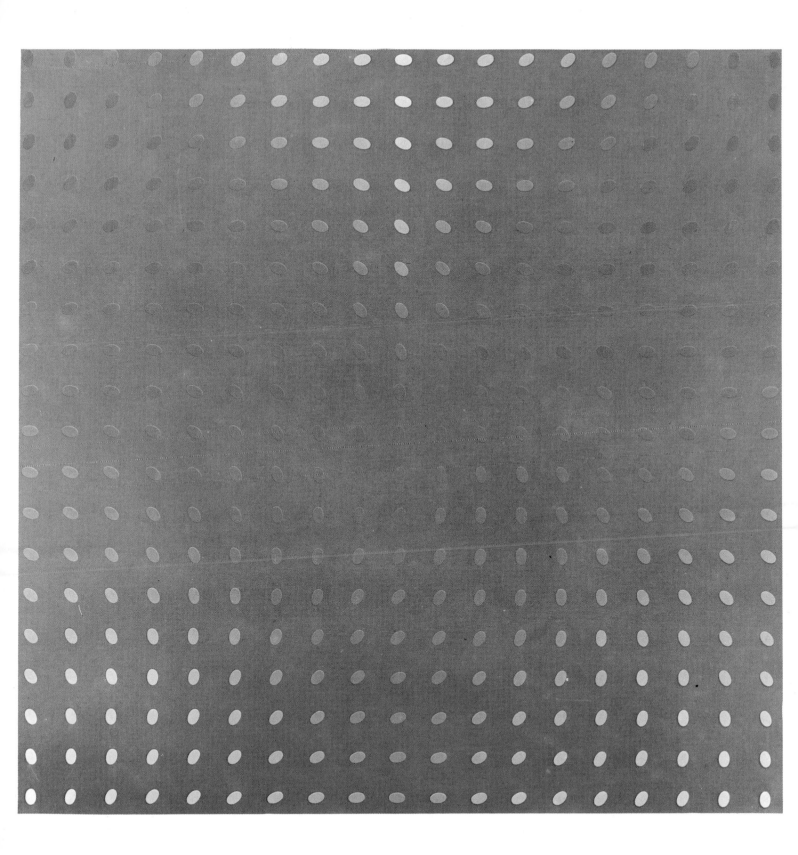

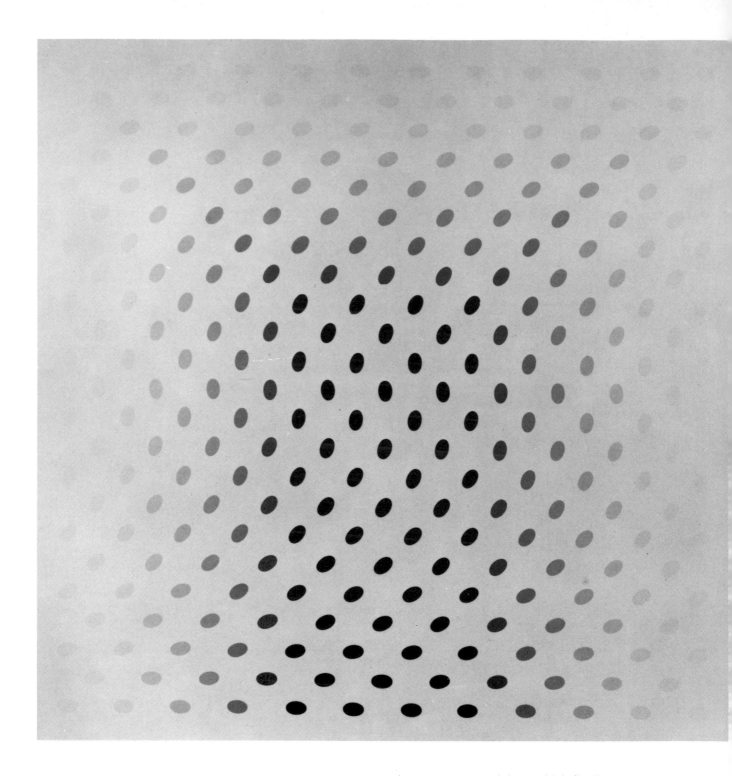

52 Print C from the **Nineteen greys** folio, 1968
Silkscreen, 30 in. × 30 in.
Dark on light contrast at the centre spreading out towards a warm grey periphery which finally reaches the same tone as the cool grey ground.

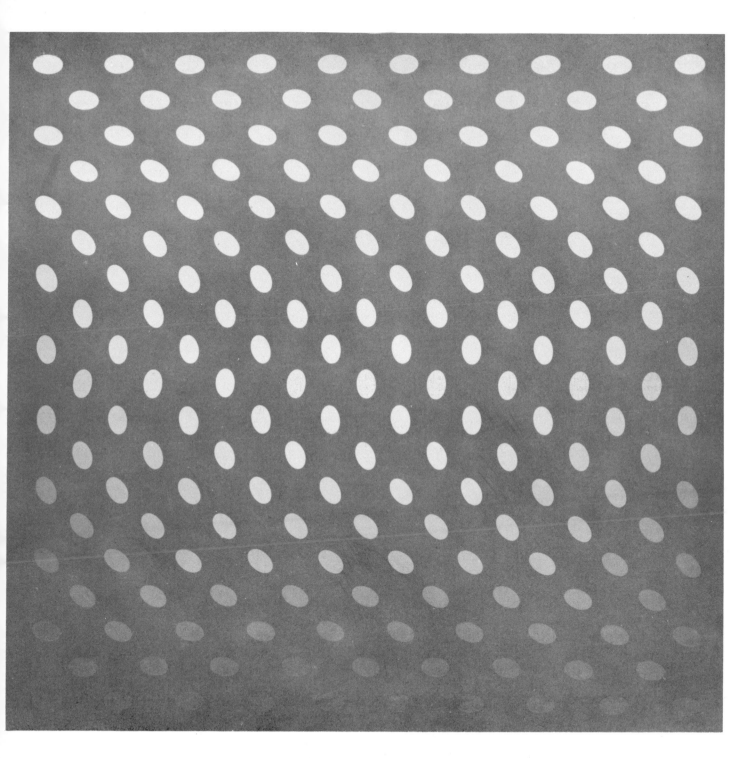

53 Print A trom the **Nineteen greys** folio, 1968
Silkscreen, 30 in.×30 in.
The pale cool ovals deepen to a blue grey at the
base, which is the same tone as the warm grey
ground, and lighten on the dark contrast at the top.
See Gene Baro, 'Bridget Riley's *Nineteen greys*',
Studio International December 1968.

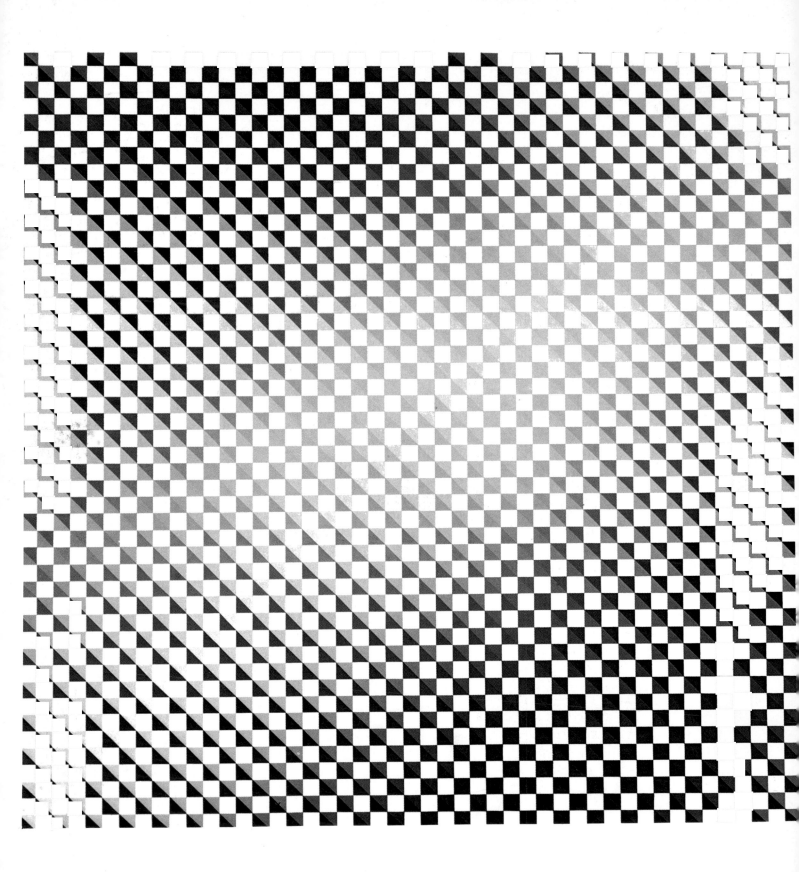

4 Search 1966
Emulsion on board,
35¼ in.×35¼ in.
A tonal sequence sep-
arated into identical
scales of warm and cold.
While the linear structur-
ing, vertical, horizontal
and diagonal, remains
constant, the warm
groupings move hori-
zontally at a changing
rhythmic beat, the cold
diagonally in a similar
fashion.

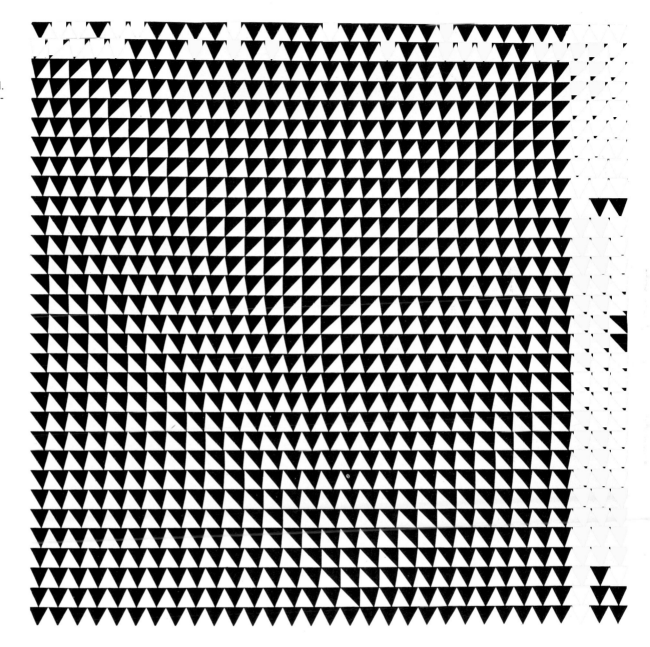

55 Shiver 1964
Emulsion on board, 27⅛ in.× 27⅛ in.
The unit used is a triangle: one point
of it moves across and back along a
straight horizontal line, while the other
two points remain constant. Over the
total structured field the sequences
change from top to bottom diagonally
and return upwards against the flow of
horizontal and vertical divisions. This
painting led on to *Burn, Turn, Deny*
and the *Nineteen greys* series of prints.

81

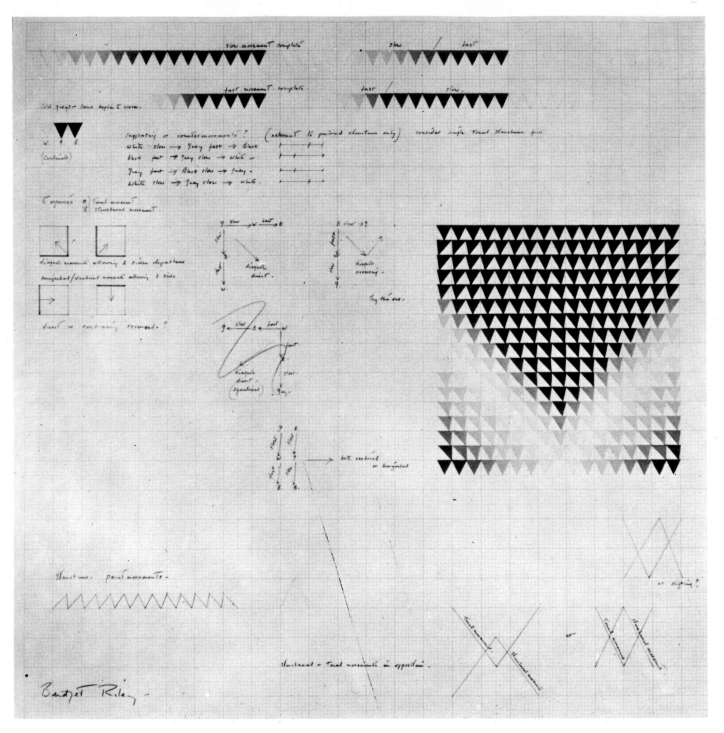

56 Structural and tonal movement in opposition
1966
Pencil and gouache on graph paper, $24\frac{1}{2} \times 24\frac{1}{2}$ in.
Closely related to *Burn, Deny* and the *Nineteen greys* series of prints. The potency of the shimmering chevron movement can already be estimated from this study.

57 Burn 1964
Emulsion on board, 22 in. × 22 in.
Two sequences, one tonal and one axial, move diagonally across regular horizontal and vertical divisions, and return in contrary directions, the tonal movement falling, the axial movement rising.

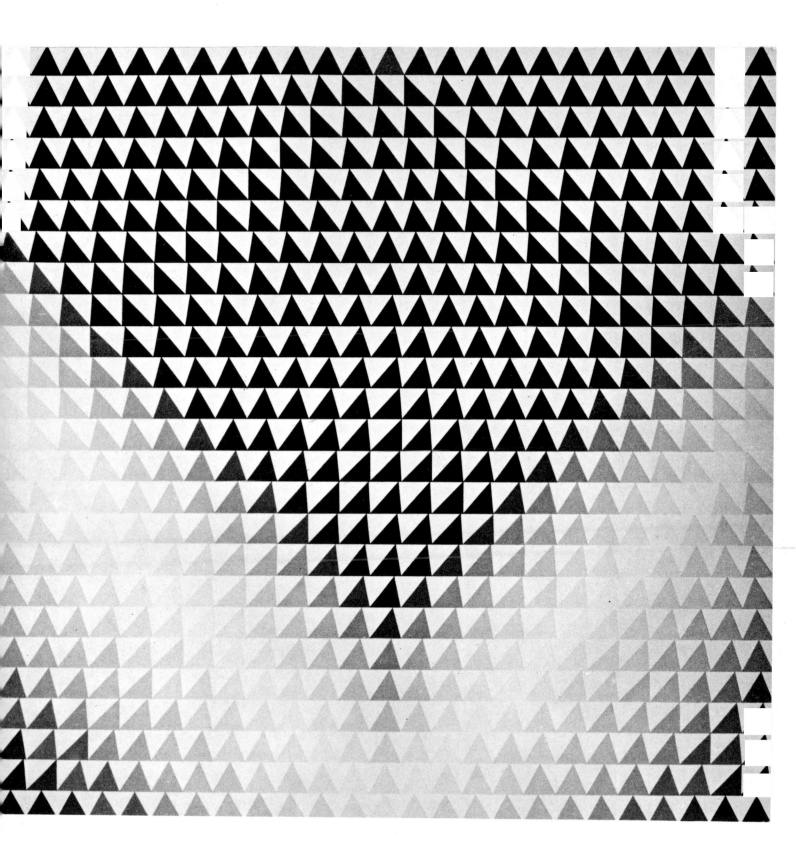

83

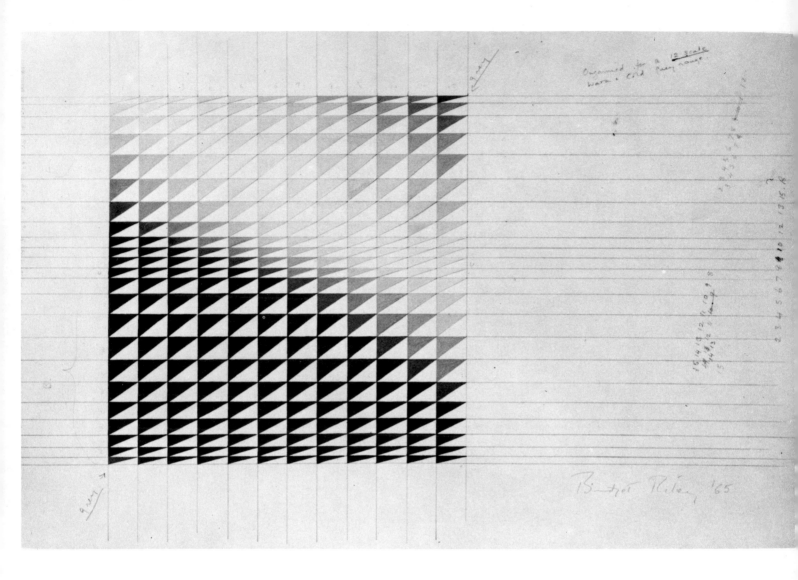

58 Untitled study 1965
Gouache and pencil on paper, 13 3/16 in. × 20 in.
Study for an unrealized painting. The vertical/
horizontal organization of triangular units relates to
Straight curve while the diagonal movement of the
grey has affinities with *Pause, Turn, Chill* etc.

59 Turn 1964
Emulsion on board, 19½ in. × 19½ in.
The units are separate, maintaining a loose vertical
and horizontal constancy; axial and tonal sequences
take on contrary diagonal directions.

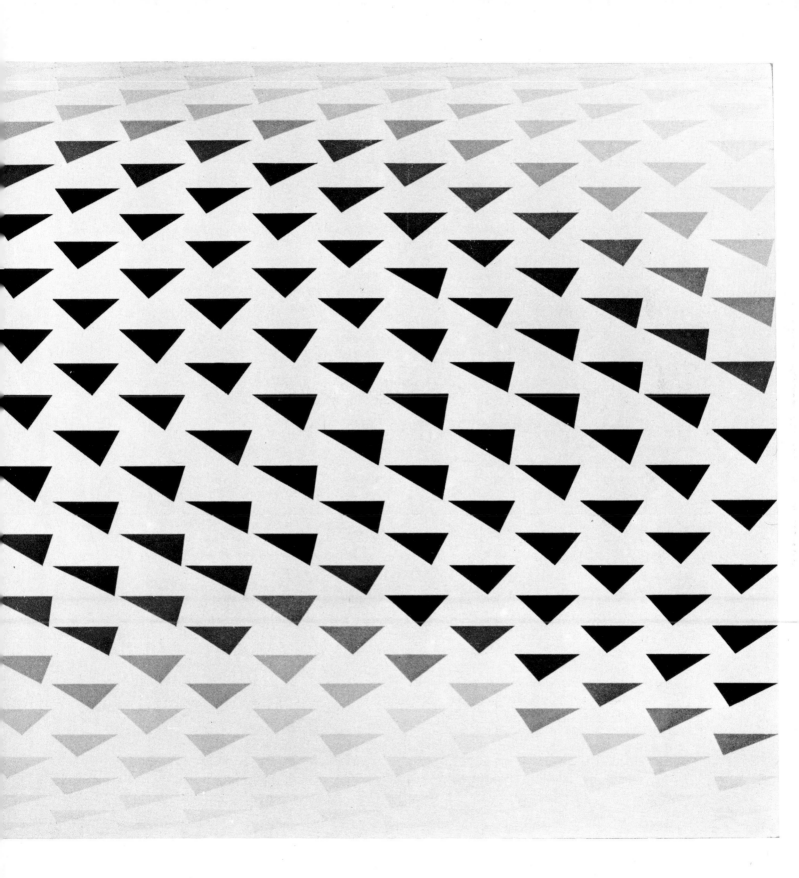

Since 1966

From the evidence of exhibited work up to 1966 it would be reasonable to assume that Riley had been concerned so exclusively with black, white, and the intermediary scale of greys, that colour was a closed field to her. Few people realize that from 1961, when she painted *Movement in squares*, she was pursuing studies in colour, but the rare instinct for self-preservation which a genuine talent possesses had consistently rejected the results, often enough, seductively pleasing images. None of them convinced her either of their fundamental structural relevance to the central issues of her work, or of their potential for more sustained investigation. The root of the trouble lay in the fact that all the precedents of which she was then aware encouraged a sort of 'head-on' confrontation with colour. Textbook colour theory, the Fauves, Matisse, Kandinsky, Klee and Delaunay all tended to emphasize working with maximum-intensity colour; by contrast, Seurat and Signac were still perhaps too close to the figurative interests that she had renounced. Kandinsky was clearly irrelevant because of his increasingly metaphysical speculations about colour and his cavalier attitude to structural function; Klee's attitude to colour, despite his apparent concern for inherent functional energies and principles, was again veiled by highly subjective circumlocutions. For a time the attraction to Delaunay was understandably strong.

Delaunay had committed his art to an attempt to extend the understanding of optical energies implicit in response to colour: his concept of dynamism was wholly dependent on such energies. His work had its origins in Neo-impressionism and more particularly in the colour-theory of Chevreul, sources to which Riley herself had made reference, and his work was not confused either by naturalistic, supernaturalistic, symbolic or other intellectualized pre-conditioning. The emphasis that he placed on rhythmic simultaneity: 'The movements I mean – I experience them vividly; *I do not describe them. Through their contrasts they are simultaneous – not succesive*' [14], was essentially in line with her own discoveries, but the concentration of attention on a full-strength spectral palette, on complementaries and powerful simultaneous contrasts, temporarily misled her into concentrating on too wide and too powerful a field of colour involvement; she was unable to evolve colour-form (a structural identity) as distinct from coloured forms (a decorative adjunct) relative to the creative aim she had set herself. As she confessed to me at a later date 'it was very alarming at the time to keep finding one avenue after another leading nowhere'. Certainly her knowledge of such basic colour phenomena as irradiation (e.g. the tendency of white to 'spread' on black), after-images, and the general principles of colour contrast had increased.

But it was not as the result of a dramatic demonstration of colour-theory that the break-through was achieved, but by the quietest and most gradual infiltration of her already established black-grey-white situation. The introduction of greys had led to their being organized into gradated tonal scales, a number of 'warm' greys and an equal number of 'cold' greys forming a sort of limited keyboard of colour. A decision to substitute two positive colours, red and turquoise, for the 'warm' and 'cold' extremes,

and to replace a tonal scale by a gradated colour scale, marked the end of the equivocation about the introduction of colour.

The series of paintings *Cataract* (see pp. 101, 103) come from this period, and in the fifth painting of that series a new phenomenon made its apearance which will be discussed later. In the painting *Chant 1* (see study on p. 102) which followed, all formal variety was abandoned and the structure was entirely subordinate to the demands of the colour: stripes in widths determined by the proportional needs of the colour. The two colours, red and turquoise, alternating in bands of one colour encased by bands of the other, gave rise to an interesting spatial reading: the spatial effect was much more pronounced in the vertical position. But, also, subsequent working proved that the space sensation was not dependent on the use of red and turquoise but resided in the fact of there being equal tonality of 'warm' and 'cold' colour. Similar structurings were developed in red and blue and magenta and green. From this *Chant* series came *Late morning*, now in the Tate Gallery (see pp. 104 and 105); again structurally constant in vertical bands across the entire canvas, one colour, red, remains constant while green-to-blue divided into ten regular steps is paired with the red to form changing relationships. Optical fusion takes place, the blue mating with the red producing a violet tendency, the red with the green giving rise to a yellowish sensation and, over the whole painting, a sort of subtle tidal wave of colour is perceptible in the whites. 'The strangely iridescent disembodied colours', noted by Ehrenzweig in the works of 1962/3, had emerged again and spread across the centre of this impressive painting.

This new phenomenon, an 'hallucinatory' optical colour appearing to spread into the whites, revealed itself with the adoption of the red-turquoise dialogue. Speaking of this recently, Riley said:

About six years ago I got hold of a little book on colour theory that Harry Thubron used to mention, *Colour*, by H. B. Carpenter, and there is one bit in it that particularly caught my attention, where he talks about outline and its effect upon colour: 'The effect of a coloured outline may be to produce a wonderful glow, provided that the colour is bright enough and that the enclosed forms are both small and numerous... The outline itself will not be visible at a short distance, but the change of colour resulting from its use will be very noticeable.' [15] Now even in the small illustrations, cheaply printed, that accompany the text one can observe the phenomenon of 'colour-spread', colour irradiation. I remembered this and thought that I would someday make a whole series of experiments on this. Possibly as a later consequence of this, over the last few years I've been fascinated by lettering on delivery vans: it's a favourite trick of lettering artists to outline letters with a colour.

To further induce these disembodied colours, Riley changed to the use of orange, green and violet (see *Orient 1* (orange, green and violet), pp. 106 and 107, and *Rise 1* (orange, violet and green), pp. 110 and 111), and more recently to cerise, turquoise and olive (see p. 119), because they are all least fixed in their identity, they are all mixtures and lie between more dominant colours, and consequently their identity can be influenced, they can be readily 'shifted', and they prove to be equally irradiative.

As in every other decision she has taken, it is grounded in experience and owes nothing to theory (there are sure to be those who will be anxious to point out that, with red taking the place of orange, she would be nearer to the physicists' three-colour theory). In all that she does she declares herself a true descendent of the phenomenologists, rejecting pre-suppositions (theoretical or habitual) and looking for the extension

of her knowledge through the direct engaging of her senses and her total consciousness. The previously accepted trichromatic theory is, in any case, now under attack from Hurvich and Jameson's 'opponent-colours' theory, based on the four colours of Hering paired in two sets: a yellow-blue pair and a red-green pair together with a black-white pair. It not only takes account of the six unique colour sensations, red, yellow, green, blue, black and white, but also of most colour vision defects and the appearance of 'purity', 'similarity' and 'dissimilarity' among the colours in the colour circle. Might it also throw light on the phenomenon that Riley in her intuitive fashion has uncovered? As yet little seems to be forthcoming from the scientists about this phenomenon, it does not seem to operate consistently within the present theory of colour after-images, and as a manifestation of colour irradiation it is certainly complex. In a recent paper 'Colours under scrutiny' contributed to a collection of articles on optics, Professor W. D. Wright, Professor of Applied Optics at Imperial College of Science and Technology, London, writes of this type of phenomenon:

> The interaction between colours located alongside each other generally produces an enhancement of the contrast between them. This can be explained, at least in general terms, as due to lateral inhibition between the neighbouring areas of the retina on which the colours are focussed. Yet with some types of pattern, especially fine striped patterns, a reverse effect seems to occur. This is in part due to the physical spreading and scattering of the light on the retina, but quantitive studies of the colour changes suggest that more subtle factors must also be at work. [16]

The entire area of colour perception is as lively a subject for investigation as it has ever been. Yet here again we should be careful not to assume that Riley's preoccupation is with the investigating of perception. Throughout her ten years of development, the decisions she has taken have always related to the object as a manifestation of art, not of science.

Riley is frequently questioned about the use of computers in her work and as to whether she has considered their relevance to what she is doing. It invariably causes embarrassment because it springs from a fundamental misconception about her work, if not from a misconception about the nature of computers. Firstly, as a data-processing machine the computer is dependent on the skilled feeding of data to it, from which it evolves a total general system capable of answering particular problems lying specifically within the field of the data initially supplied. The formulation of the data in this case would raise certain crucial problems. From data that could be elicited from a representative selection of Riley's work the computer would be capable of formulating the maximum number of variants that could emerge from this induction. But Riley, unlike Vasarely, is entirely uninterested in this 'global' potential; for example, the knowledge that the elements and the type of structuring used in the *Chant* series are capable of many million variables would mean absolutely nothing to her. In terms of work in hand, the data is constantly being reappraised since it resides not in calculation in advance of perceptual verification, but in the two factors indivisibly linked. It would seem then that in determining the data to be fed to the computer, the problems would have been ostensibly solved, and in terms of Riley's needs a simple calculating machine would be as effective. This she already possesses in the form of a book of multiplication tables and her simple understanding of primary arithmetical processes. As she has so frequently insisted, the relationships which form the structure of her work are not arrived at by a system of logic or calculation alone; freedom of intuitive selection and

decision is invariably present. Being continuously in direct physical contact with the visual situation means that she is in constant touch with the emerging potentialities and problems. As she herself says, 'Who wants computers to have all the fun?'

Riley's use of studio assistants is a very different matter. Far from being merely technical extensions to the studio apparatus, they are valued for their independent skill and artistic integrity. Yet the evolution of the ideas, every decision with regard to scale, interval, colour (mixture and gradation) and total format of the structure is hers alone. But at private views of her work there is a noticeable sense of their corporate pleasure in the success of the work. Not only sheets of dimensional specifications but also numbers of trial studies are pinned about the walls until a decision is reached. In the case of some of the recent paintings, full-scale studies in colour on paper have had to be tried out before the final work has been approached. In everything, and at every stage, scrupulous precision is demanded; all colours are mixed and kept in separate labelled jars until the completion of the work, and exact specifications for re-mixing are retained. Only apparatus that is needed to ensure immaculate working is in evidence; no photographic enlargers, no mechanical colour-mixers, no light-boxes, nothing which would remove any phase of the work from the most immediate physical proximity, and intellectual control. The studio-workshop is white throughout, including chairs and the enormous working table; no nuance of colour escapes notice in these surroundings.

On the question of the place of art and artist in the social context, while being saddened and disappointed that art is accorded so mean a position by society and artists regarded as second-class citizens, Riley nevertheless considers that the very profundity of his aspirations will often and inevitably set the artist apart from society. Vasarely's ideal of a social art with the artist as a creator of prototypes is valid for him because the nature and style of his art make it possible for him to envisage this, but what of Pollock? Certainly wide distribution has many advantages and it would seem to be a logical and practical development in the case of Vasarely, but Riley has the greatest misgivings about the sort of artist who, in order to evolve a prototype-reproduction-distribution relationship with society, conditions the development of his work (and its style) towards that end.

In her own case it has been suggested that the increased scale and structural chromatic constancy of her recent work are the outcome of her moving towards viewing her work in the context of 'a modern experimental method of creating architectural visions'.[17] This is a misreading of her work, a misunderstanding both in regard to questions of scale and chromatic values. Scale for Riley is essentially determined by the inherent demands of the structured elements or units, and the structural constancy of recent work is the result of a realization that the characteristic movement of colour is irradiation, and that energies of this kind are more effectively released in situations where the formal structure retains a constancy.

Again, any difference there may seem to be between the early works in black and white and the recent works in colour is more apparent than real. Although the earlier works frequently depend upon 'consecutive' movement, that is sequential progressions that are suddenly broken, or gradually diminished or augmented (see *Fission* p. 69, *Shiver* p. 81, *Shift* p. 67 and *Turn* p. 85), they are not necessarily scanned consecutively, and the sort of total visual emersion demanded by the recent work has always been a factor. Riley has consistently been concerned about making a whole in which the individual units or forms give up their separateness and become part of a consuming total

experience. Any gap that there may have been earlier between the structuring process and the perceptual response has been eliminated in recent works, partly as a consequence of greater experience but also as a consequence of the different nature of the problems in colour. The factors of contradiction and disruption in the earlier work are related to a linear form of creative thinking and to the production of visual energies from disjunctive structuring, whereas the recent work has been dealing with qualitative characteristics of colour, the energies emerging from the inherent power of the related colour bands.

Movement for Riley has always been conceived as *experience* in time, however fractional that may be. Illusion of movement in a spatially allusive way, that is, the idea of the description of forms in movement, has sometimes been detected in her work (*Fission, Straight curve* and *Arrest* p. 92) but it has never been more than a by-product of other intentions and never regarded as important enough to merit either elimination or intensification. The movement she has been concerned with is two-fold, firstly to do with change, in the form of variation in proportions, progressions conceived serially as time, and secondly to do with psycho-physiological sensations (the visual vibrations resulting from the structured canvas conceived as a generator) that measure time in a perceptual sense. By virtue of this element of time, the duration of the fluctuating vibration in the optical experience, and the sense of emersion in the total experience, her work has often been closer to those artists whose works are dependent on contemplative vision, such as Rothko, than to the kinetic art movement. And with the most recent work this has become even more pronounced. As David Thompson has written of *Late morning:* 'The painting itself no longer buckles and twists, jumps and sparkles with the same kind of kinesthetic energy as the more linear paintings. The energy of colour is seen to be without direction, as a beating pulse that gathers itself together, across the centre of the painting, into a steady emanation of power.' [18] Sophisticated means arrive at a subtle primitive power: it is the last in a long line of paradoxes. Throughout her work we can see the simultaneous presence of warm and cold, of harmony and contrast, of proposal and denial, of static and dynamic: the statement of paradox inheres. On the one hand, in her work the means are ordered, precise and controlled to the maximum, while on the other, the end is free, vibrating and dynamic. Our experience of this vibrating intensity is disciplined and cool, the elegance of the generative structure ensures this, and yet we are aware that these are forces capable of destroying our measured world, reducing it to chaos. As we look, we are balanced on a tightrope and our faculties are brought to a pitch of rare acuteness. To say that it is emotion that is experienced is to make do with the generalized jargon of art-criticism; it is certainly to do with feeling, differentiated to the extent of manifesting elation or repose, calm or disturbance, buoyancy or tranquillity. But beyond this is the confidence given in the reaffirmation of the unity of feeling and knowing, intuition and rationality, a special meaning for us in the twentieth century in the demonstration of a sensuous qualitative world that the technological world may hold within its mechanistic precision. Romantic alienation is challenged by a new classical equilibrium, not by discounting the past but by accepting the future, not by cloudy aesthetics but a de-mystification of art, not by exaggerated veneration of the art object but by concentration on its vitalistic structuring. The technical world is not regarded as a hostile power but as an expanding field of aesthetic creative potency; the energies that emerge from the structurings evoke a renewal of our spiritual energy.

The last word must be with Bridget Riley:

My final paintings are the intimate dialogue between my total being and the visual agents which constitute the medium. My intentions have not changed. I have always tried to realize visual and emotional energies simultaneously from the medium. My paintings are, of course, concerned with generating visual sensations, but certainly not to the exclusion of emotion. One of my aims is that these two responses shall be experienced as *one and the same*.

The changes in my recent work are developments of my earlier work. Those were concerned with principles of repose and disturbance. That is to say, in each of them a particular situation was stated visually. Certain elements within that situation remained constant. Others precipitated the destruction of themselves by themselves. Recurrently, as a result of the cyclic movement of repose, disturbance, and repose, the original situation was restated. This led me to a deeper involvement with the structure of contradiction and paradox in my more recent work. These relationships in visual terms concern such things as fast and slow movements, warm and cold colour, focal and open space, repetition *opposed* to 'event', repetition *as* 'event', increase and decrease, static and active, black opposed to white, greys as sequences harmonizing these polarities.

My direction is continually conditioned by my responses to the particular work in progress at any given moment. I am articulating the potentialities latent in the premise I have selected to work from. I believe that a work of art is essentially distinguished by the *transformation* of the elements involved.

I am sometimes asked 'What is your objective?' and this I cannot truthfully answer. I work 'from' something rather than 'towards' something. It is a process of discovery and I will not impose a convenient dogma, however attractive. Any artist worth consideration is aware that there is art beyond art-movements and slogans, that dogma can never encompass the creative process. There is art beyond Op art, an art which engages the whole personality and draws a similarly total response from society.

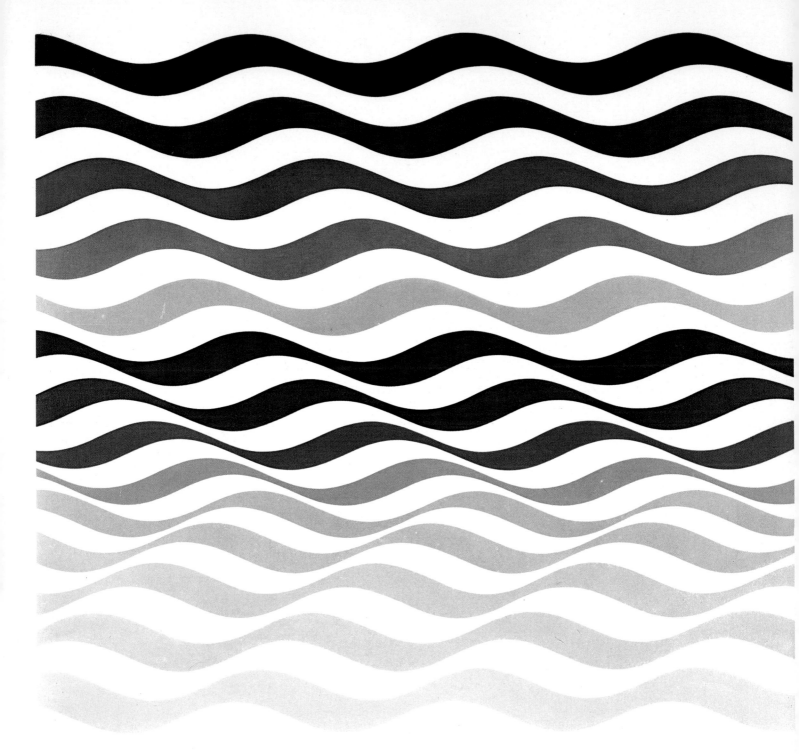

60 Arrest III 1965
Emulsion on canvas, 69 in. × 75½ in.
Flowing undulating bands, not to be read as lines but
as agents for carrying colour, move across the canvas
horizontally at a rhythmic pulse determined by two
diagonal movements travelling at different speeds,
structuring the crests of the undulations. Warm and
cold tonal sequences move vertically.

61 Drift I 1966
Emulsion on canvas, 70 in. × 68¾ in.
A cold tone remains constant over the whole area,
while from left to right a warm sequence moving at
two rates gives rise to warm/cold contrast, gradually
changing to light/dark contrast in the central area
and moving away again into warm/cold contrast.
Diagonal movements at two different speeds power-
fully influence the curving bands flowing from top to
bottom. The climax of the tonal sequence and the
climax of the curve movements are at variance.

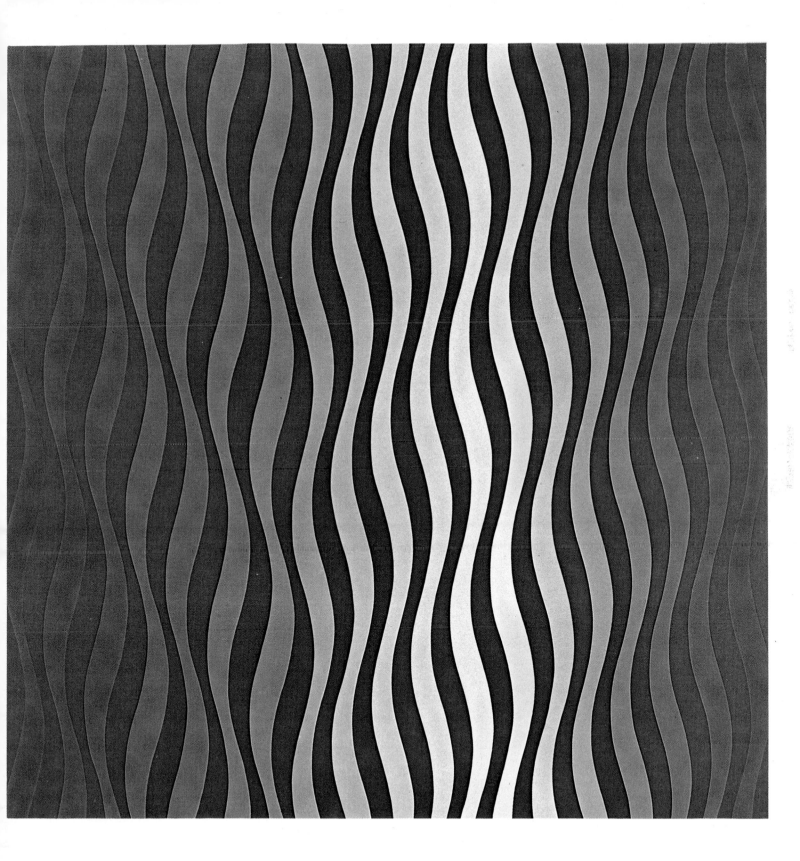

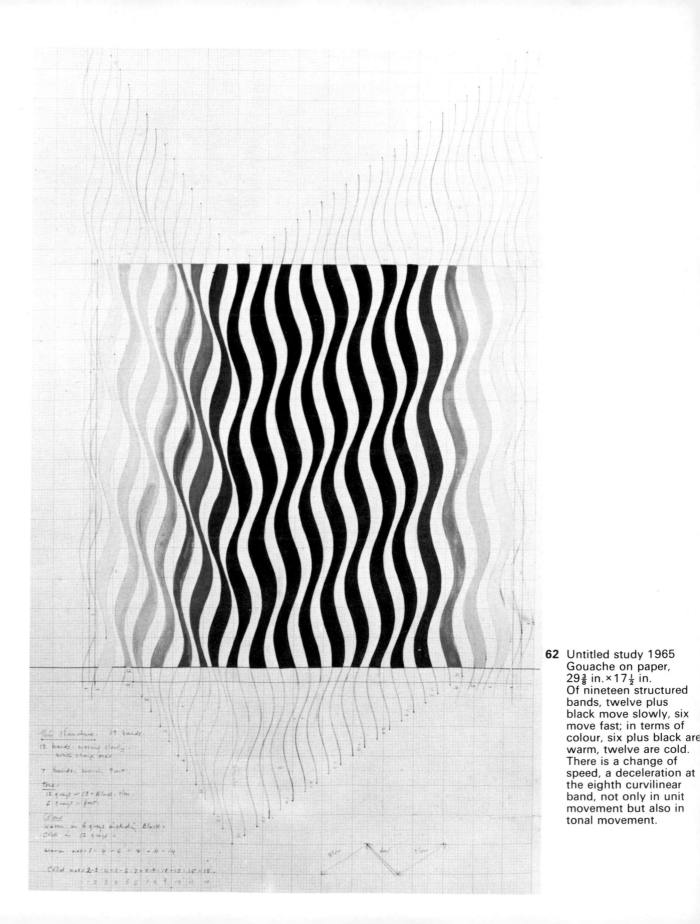

62 Untitled study 1965
Gouache on paper,
29⅜ in.×17½ in.
Of nineteen structured
bands, twelve plus
black move slowly, six
move fast; in terms of
colour, six plus black are
warm, twelve are cold.
There is a change of
speed, a deceleration at
the eighth curvilinear
band, not only in unit
movement but also in
tonal movement.

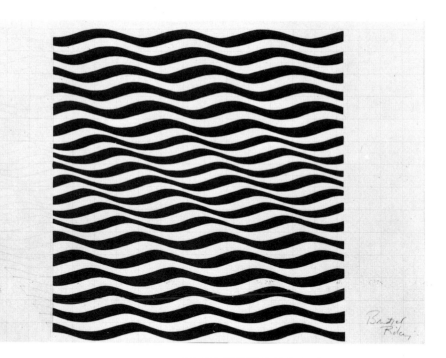

63 Early study for **Arrest** series 1967
Gouache on graph paper, 14½ in.×31 in.
Concerned with tempi and the incline of the curve
unit.

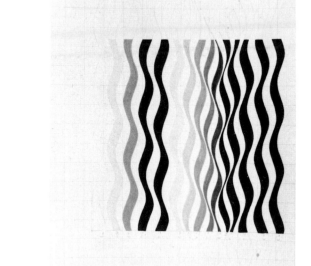

64 Study for **Arrest** series (image B, tonal structure I)
1965
Gouache and pencil on graph paper, 28 in.×13½ in.
The curve slowly descends and rapidly climbs
arabesque inclines, counter-pointed by the fast/slow
tonal movement. The warm/cold order is annotated
on the drawing.

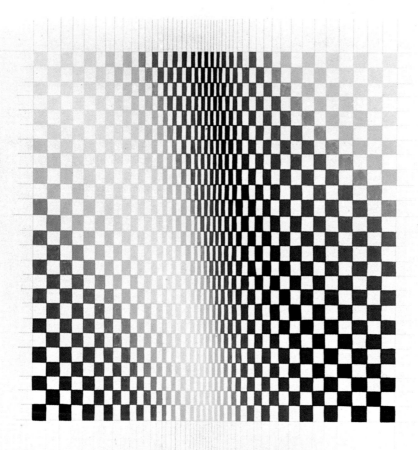

65 Untitled early colour study 1965
Gouache on paper, 35½ in.×24¾ in.
Faulted for being a 'coloured form',
rather than the 'colour form' for which
Riley was searching. The bleaching

downward thrust is related to *Loss,
Pause*, etc., the colour movement being
a subtle inversion of blue, through
green to yellow.

66 A curve study 1966
Gouache on graph paper,
24½ in.×16½ in.
Orange-, violet- and
green-greys change the white
curves through colour irradiation.

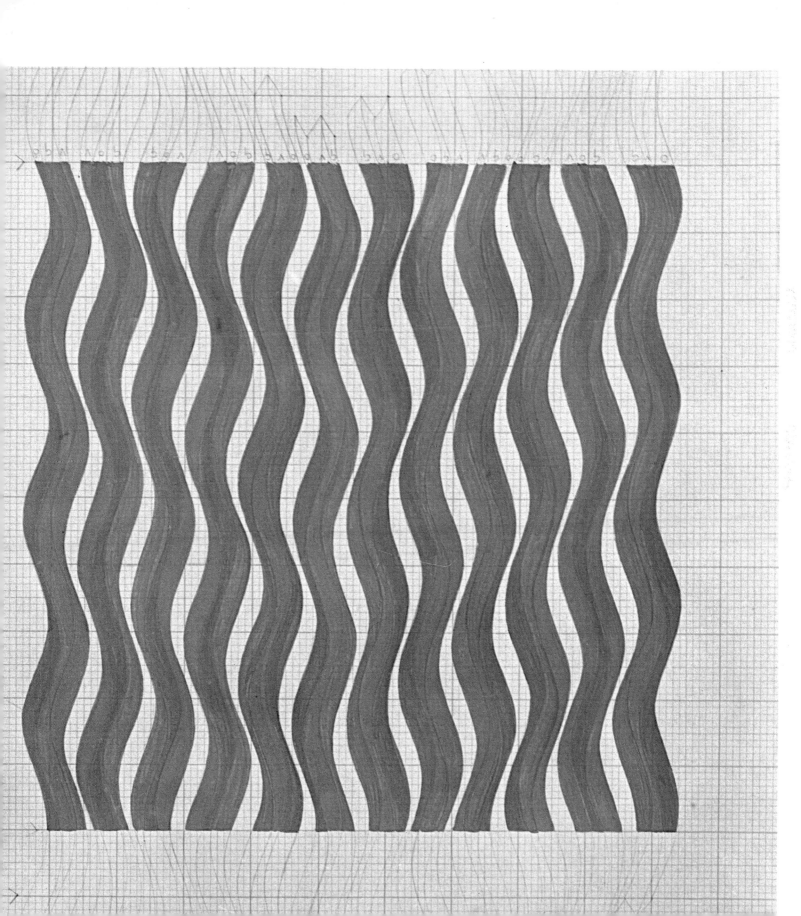

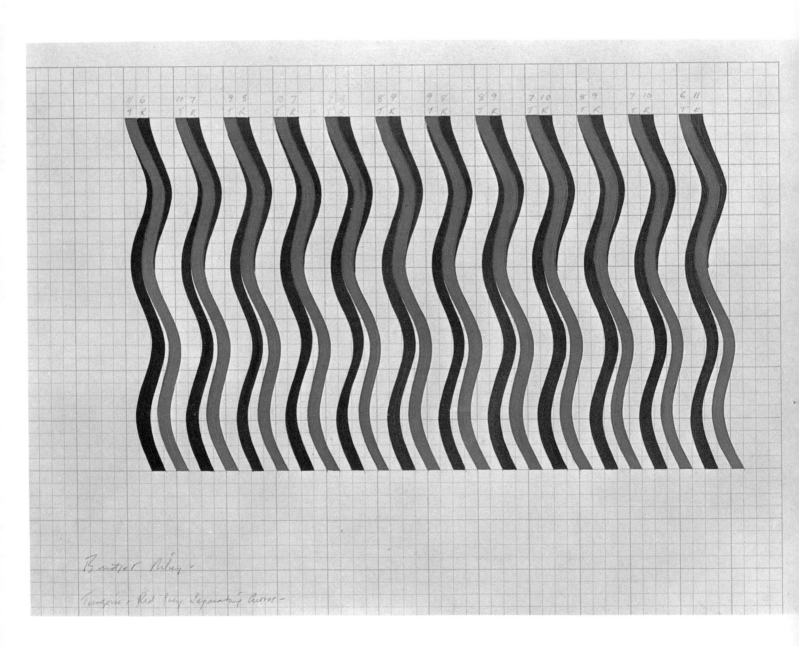

67 Turquoise and red study 1967
Gouache on graph paper, $7\frac{1}{2}$ in.×$40\frac{5}{8}$ in.
A key study of warm/cold relationships.

68 Untitled study 1967
Gouache on graph paper, $11\frac{1}{2}$ in.×
$15\frac{1}{2}$ in.
Turquoise- and red-grey separating
curves.

69 Red crossing turquoise elongated
triangle study 1968
Gouache on paper, 40 in.×$10\frac{1}{8}$ in.
Anticipates the large canvas *Orient II* (pl. 78).

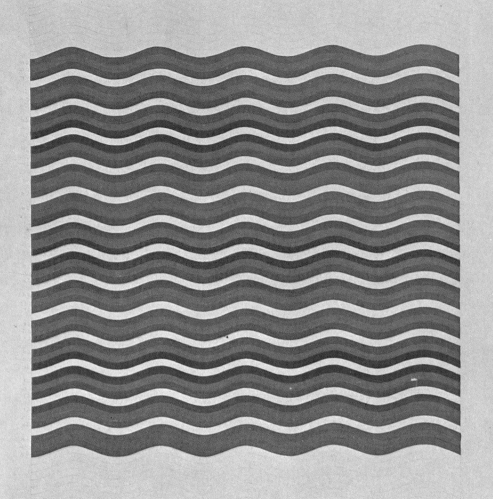

70 Untitled study 1966
Gouache on paper.
The curves remain constant; red-greys and turquoise-
greys in reduced sequence provoke a change in the
white curves by 'colour spread'.

71 **Cataract III** 1967
Emulsion on canvas, $87\frac{1}{2}$ in. × 88 in.
The linear field becomes a constant, each curve a pair
of greys, one a degree of turquoise and one of red.
From a mutual grey at the top, the two colour tend-
encies move towards purity in the lower part of the
painting. Having achieved this purity of colour they
move rapidly back again towards mutual grey at the
base.

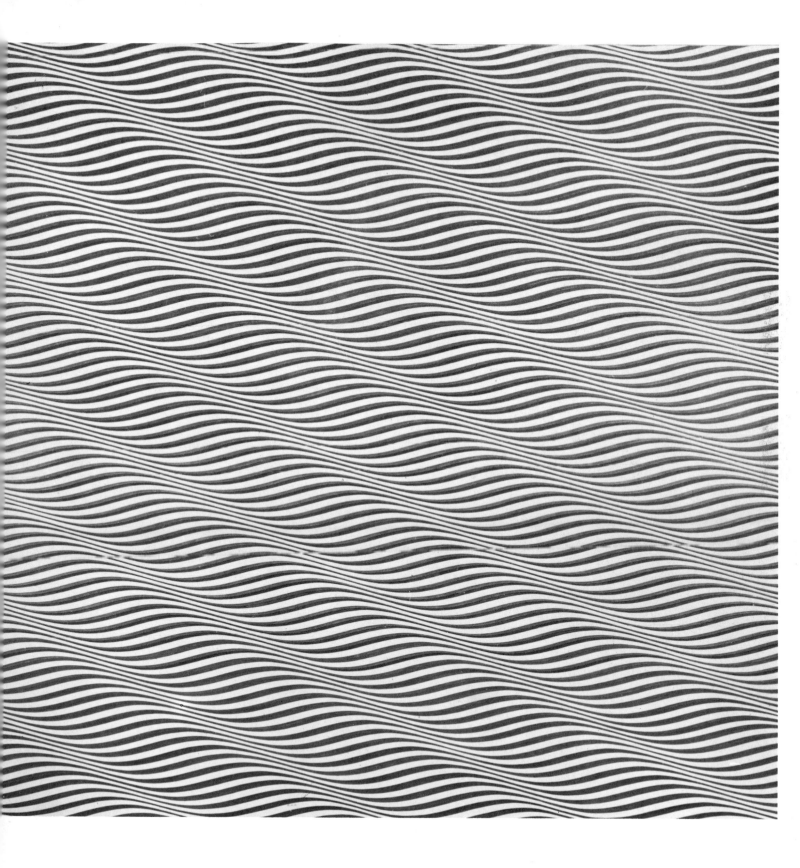

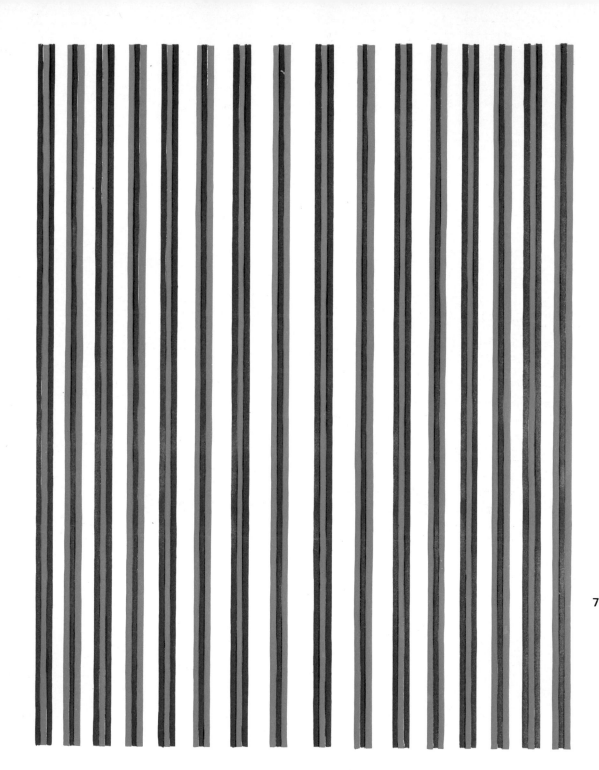

73 Cataract V 1968
Emulsion on canvas,
75⅝ in.×80 in.
The warm and cold polar-
ities are here represented by
red-grey and turquoise-grey.
The undulating curve move-
ment remains constant. This
is one of the first paintings
in which the whites appear
to change by the particular
form of irradiation known as
adjacent colour-spread.

72 Study for **Chant I** 1967
Gouache on paper, 40 in. × 27 in.
Width of each white vertical remains constant; the red and turquoise bands surround each
other giving rise to changes in colour identity in turn.

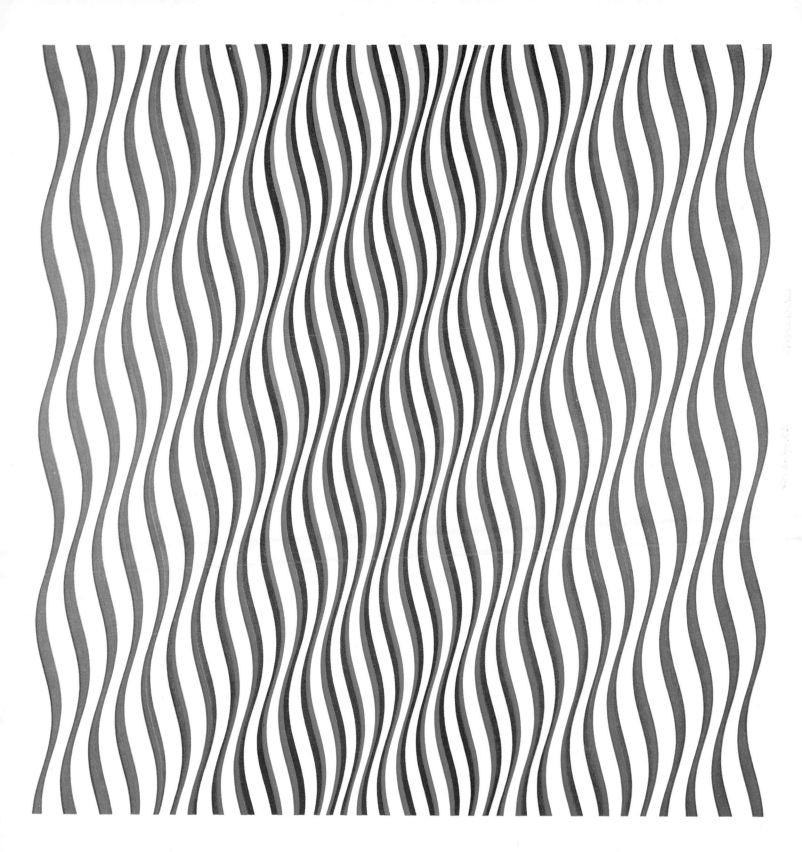

103

74 Late morning 1967
Emulsion on canvas, $88\frac{7}{8}$ in. × $141\frac{5}{8}$ in.
Structurally constant throughout; between red bands
the whites are narrower than between blue/green
bands; red and white bands do not vary in colour,
the moving disruptive element is provided by the
serially gradated scale of blues and greens.

75 Study for **Late morning** 1967
Gouache on paper, 40 in. × 40 i

76 Orient I (orange, green and violet) 1969
Emulsion on canvas, 80 in. × 133¼ in.
Orange, green and violet elongated triangles are
so structured that the sequential change is accom-
panied by a change of colour identity and a change
in the colour of the whites. The apparently random
organization subtly engineers an unemphatic order.

77 Study for **Orient I** 1968
Gouache on paper, 40 in. × 23⅝ in.

106

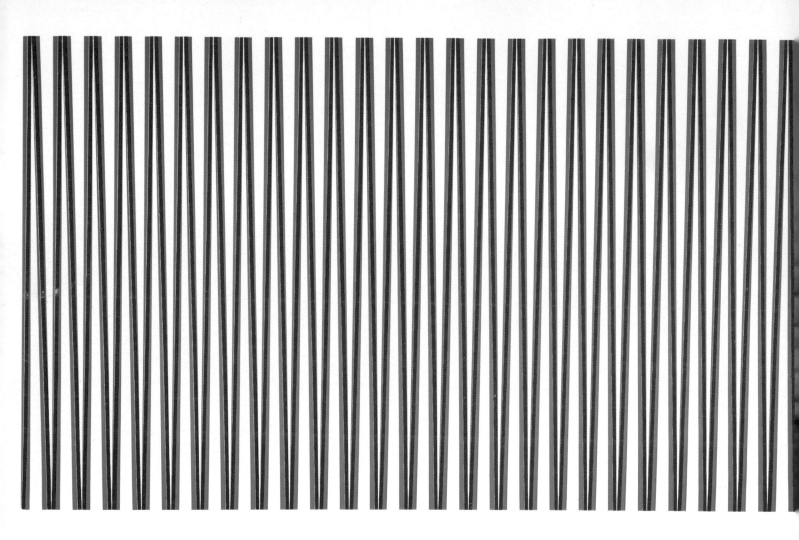

78 Orient II (magenta crossing green) 1969
Emulsion on canvas, 86 in. × 139⅝ in.
Elongated triangles are banked by struts of colour that cross each other to create
alternating contiguities.

9 Breathe 1966
Emulsion on canvas, 117 in.×
82 in.
A late development from *Hero*
anticipating the elongated triangle
form used in the 1969 *Orient*
series. In *Breathe* the corner
right-angle on the left moves over
slowly, by point movement, to a
reversed right-angle at the right
corner.

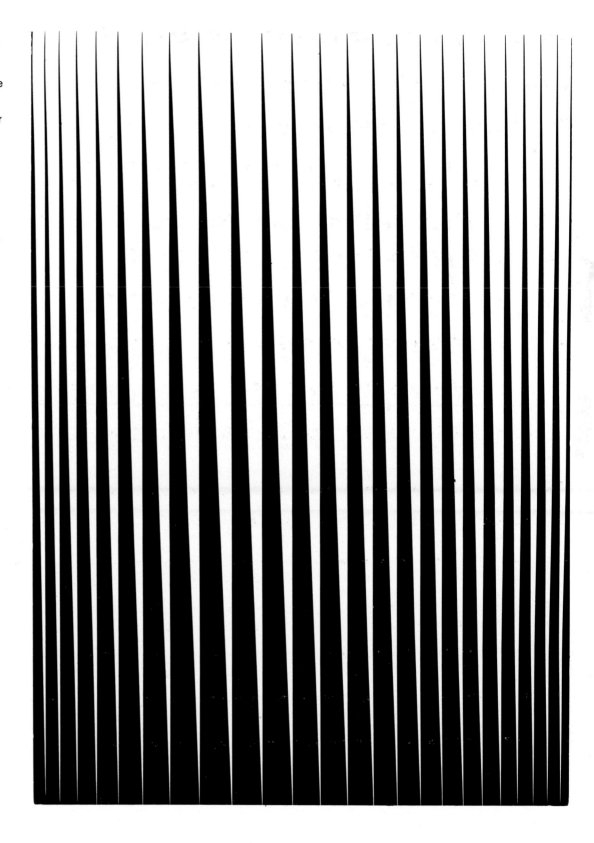

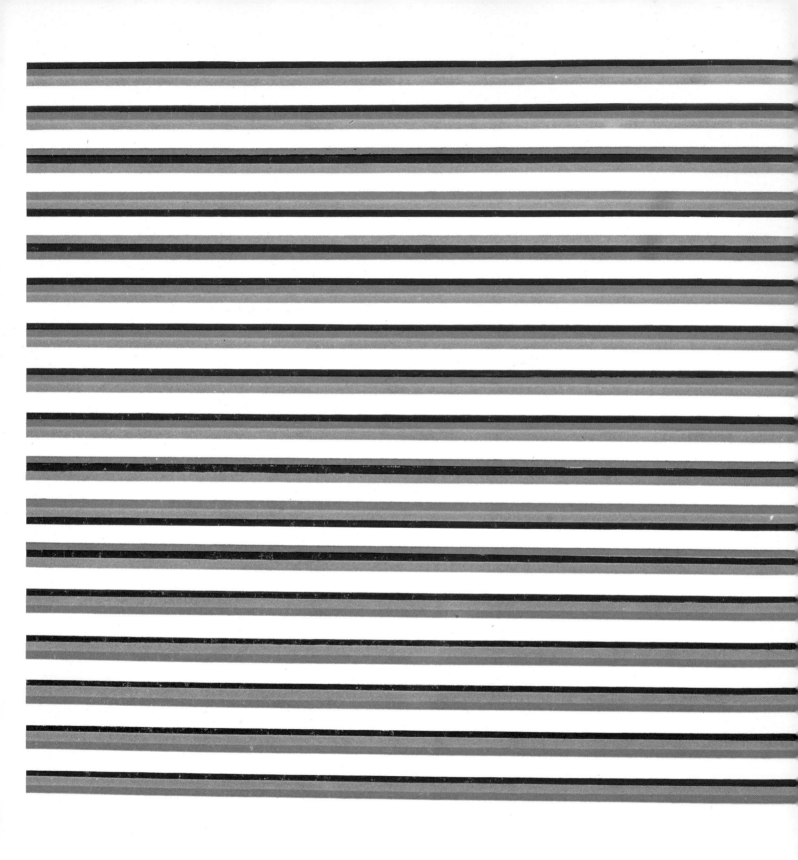

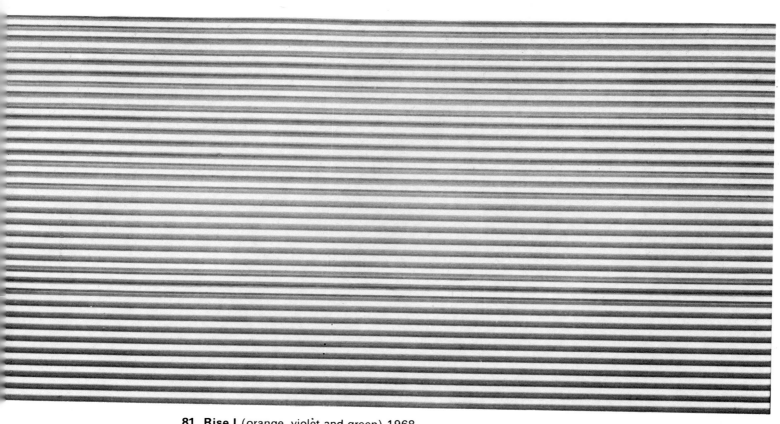

81 Rise I (orange, violet and green) 1968
Emulsion on canvas, 74 in. × 148¼ in.
A horizontal format was selected in
order to diminish spatial qualities.

80 Detail of **Rise I** 1968

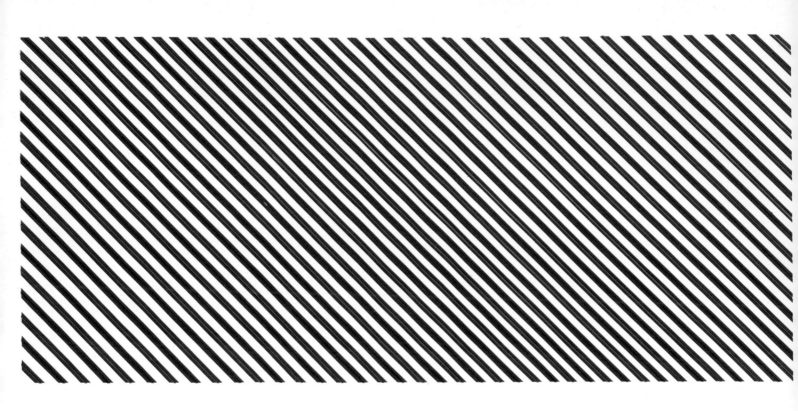

82 Byzantium (red/blue and red/green) 1969
Emulsion on canvas, 65 in.×146 in.
The identity of the red is shifted by the colour of the
band it encloses. The whites which expand as they
move outwards, are suffused with a delicate colour
spread from the adjacent reds. The painting developed
from a green and magenta canvas which is closely
connected to the *Chant* series.

83 Pale blue, magenta and green study 1969
Gouache on paper, 37 in.×27 in.
Developed from the *Chant* studies. The whites expand
centrally, each affected by the colour spread generated
by its adjacent pair of colours. The width of the
bands of colour is constant but the green-whites are
proportionally wider throughout than the blue-
whites, green being the stronger spreading agent.

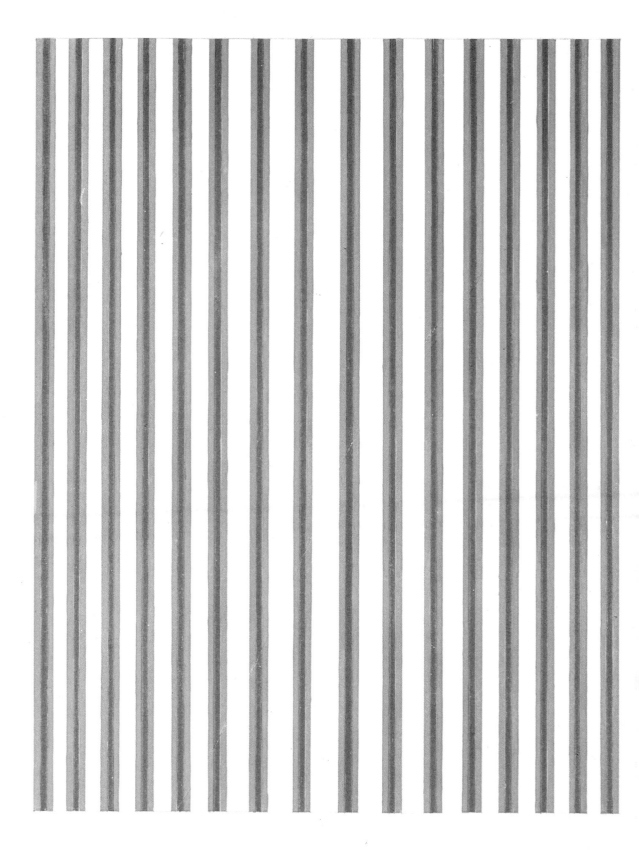

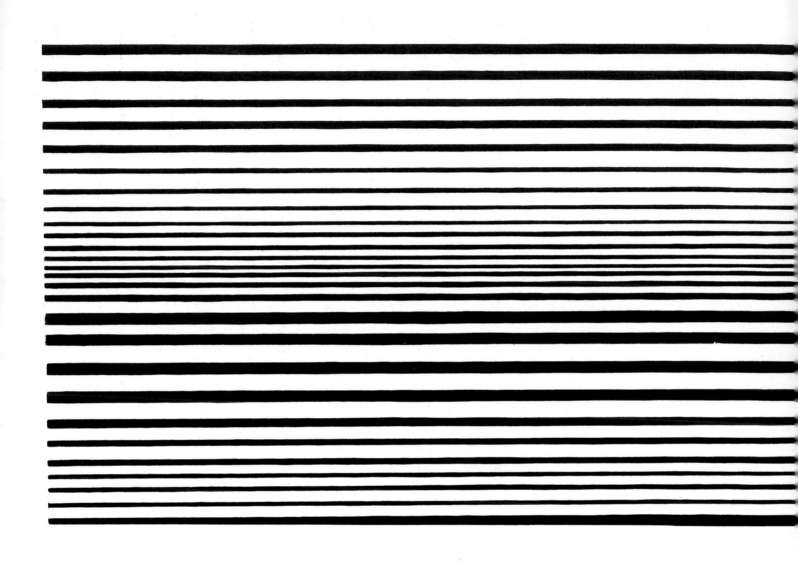

84 Horizontal vibration study 1961
Tempera on board, 17½ in.×55½ in.
A study in contraction/expansion energies, based on
the same principle as *Movement in squares* but
utilizing continuous bars of black and white.

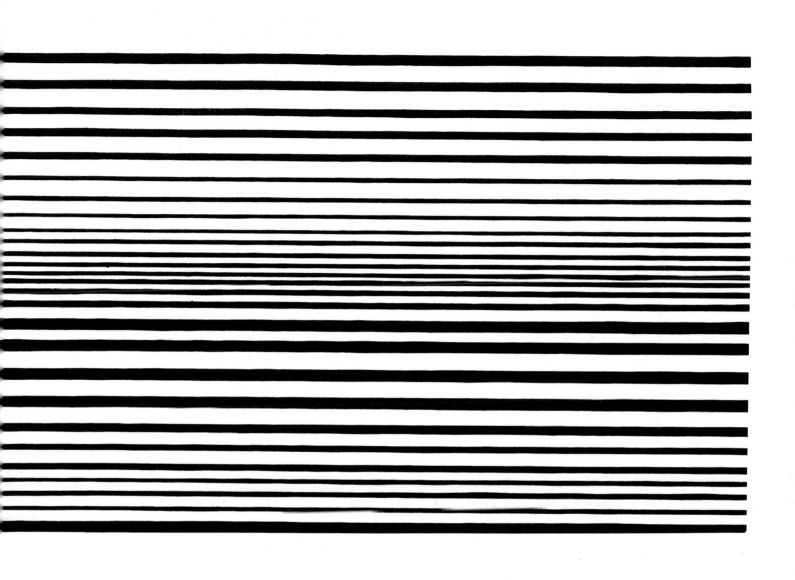

85 Study of dark green bands crossed by magenta 1970
Gouache on paper, 40 in.×11⅛ in.

86 Study of light green bands crossed by rose, lilac and orange 1970
Gouache on paper, 40 in.×16 in.

Both studies are developments from *Orient II*. Operative white widths are established relative to the spreading energies of the two groups of colours. The straight parallel bands of colour are optically curved by the interior diagonals.

87 Cerise, olive and turquoise band study
1969
Gouache on paper, 40 in. × 13¼ in.
Complex colour spreads and identity shifts
arise from crossing turquoise and olive bands
with cerise.

88 Pale magenta, blue and green band study 1969
Gouache on paper, 40 in. × 13½ in.
Uses same crossing structure as plate 87 but
in parallel band format.

Bryan Robertson *Spectator* 2 May 1969

What is useful to understand here is that Riley's paintings are not just logically enlarged transferences on to canvas of drastically simple juxtapositions among smaller basic shapes, dots or lines in rhythmic movement first set out on paper in neat little sectional patterns. Her paintings are *acts of imagination* in precisely the same way as a Mondrian or a Botticelli.

They have a deceptive ease and simplicity about them (but only at first glance) because of their great clarity and refinement; above all, because of their insistence in concentrating without digression upon the full implications of one particular principle at a time. In this sense what Riley does turns from a formal exercise into a romantic visual poem. For what this principle yields up in each case is astonishing in terms of interior dialogue, expressed by a wholly unexpected range of disclosures relating to colour, light, slow or fast speed, spatial thrust into or away from the surface, and the spill over into virgin white areas of warmth or coldness from adjacent but sharply constrained strips of pure colour.

89 Study using cerise, turquoise and olive bands 1969
Gouache on paper, 35¼ in. × 40 in.
Cerise, turquoise and olive, when extended in the direction of spectral change, return to orange, violet and green.

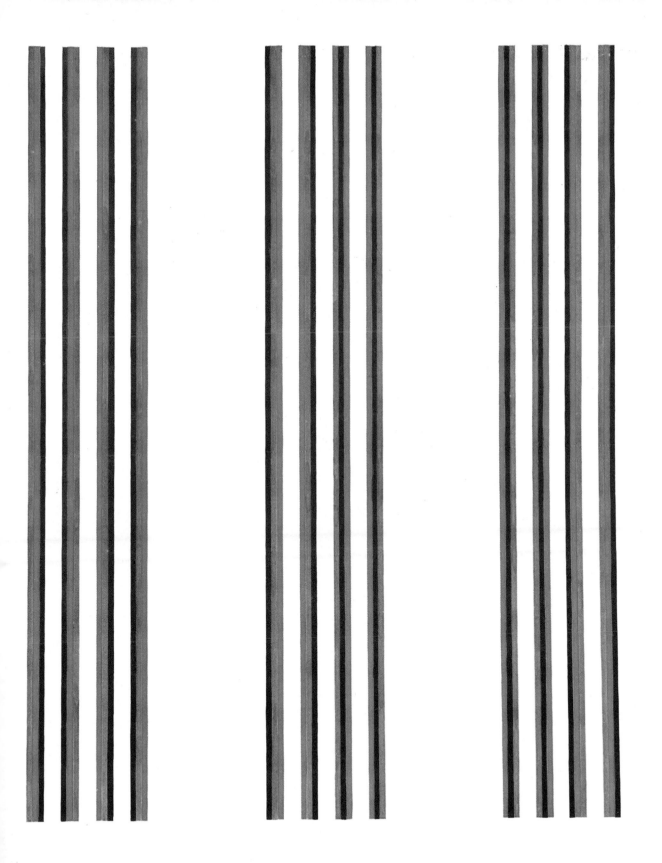

Notes to the text

1 Frank Popper, *Origins and development of kinetic art*, London/New York, 1968, p. 96.

2 Charles Biederman, *The new Cézanne*, 1958, p. 65.

3 Bridget Riley, *Art News*, New York, October 1965.

4 E. Mach, *Analysis of sensations*, 1914, p. 10, n. 1.

5 Bridget Riley, *Art News*, New York, October 1965.

6 Mondrian, Natural reality and abstract reality, 1919/20.

7 Mondrian, *De Stijl I*, 1917.

8 M. Seuphor, *Mondrian*, New York, 1956.

9 M. de Sausmarez, 'The artist in a scientific society', *Universities Quarterly* Vol 4, No. 4.

10 Charles Blanc, *Grammaire des arts du dessin*, Paris 1867; translated by K. N. Dogget, Chicago 1879, p. 40.

11 P. Serusier, *ABC de la peinture*, Paris 1921, p. 21.

12 *Stravinsky in conversation with with Robert Craft*, Harmondsworth, England 1962, p. 34.

13 Anton Ehrenzweig, *The hidden order of art*, London 1967, pp. 84-5.

14 R. Delaunay, *Du Cubisme à l'art abstrait*, Paris 1957, p. 184.

15 H. Barrett Carpenter, *Colour*, London, 1923.

16 Professor W. D. Wright, 'Colours under scrutiny', *New Scientist*, London, 10 July 1969.

17 Frank Popper, *Origins and development of kinetic art*, London/New York 1968, p. 192.

18 David Thompson, *Bridget Riley* (catalogue introduction 1), Venice Biennale, June 1968.

Exhibitions, collections and awards

One-man exhibitions

1962 Gallery One, London

1963 Gallery One, London
University Art Gallery, Nottingham

1965 Richard Feigen Gallery, New York
Feigen-Palmer Gallery, Los Angeles

1966 Robert Fraser Gallery, London (prints – with Harold Cohen)
Robert Fraser Gallery, London (drawings)

1966–67 Richard Feigen Gallery, New York (drawings) and tour of USA by Museum
of Modern Art, New York

1967 Richard Feigen Gallery, New York

1968 XXXIV Biennale, Venice (British Pavilion – with Phillip King)
Städtische Kunstgalerie, Bochum
Museum Boymans-van Beuningen, Rotterdam (with Phillip King)

1969 Rowan Gallery, London
Bear Lane Gallery, Oxford; Midland Group Gallery, Nottingham; and
Arnolfini Gallery, Bristol (drawings)

Mixed exhibitions

1955 *Young Contemporaries*, R.B.A. Galleries, London

1958 *Diversion*, South London Art Gallery
Some Contemporary British Painters, Wildenstein Galleries, London

1959 Bradford City Art Gallery Spring Exhibition

1962 *Towards Art?*, Royal College of Art, London (and subsequent Arts Council
Tour)

1963 *1962, One Year of British Art*, selected by Edward Lucie-Smith, Tooths

90 Bridget Riley

Gallery, London
Ten Years, Gallery One, London
John Moores Exhibition, Walker Art Gallery, Liverpool

1964 *6 Young Artists*, Arts Council Touring Exhibition
Marzotto Prize Exhibition
Englische Kunst der Gegenwart, Städtische Galerie, Bochum
Nouvelles Tendences, Musée des Arts Décoratifs, Paris
New Generation, Whitechapel Art Gallery, London
Painting and Sculpture of a Decade, Tate Gallery, London
Carnegie International, Pittsburgh
Young Artists Biennial, Tokyo
Summer Group Exhibition, Robert Fraser Gallery, London
Seven, '64, MacRoberts and Tunnard Gallery, London
Rule Brittania, Feigen-Palmer Gallery, Los Angeles

1964–65 *Contemporary British Painting and Sculpture*, Albright-Knox Art Gallery, Buffalo, NY
Motion and Movement, Contemporary Arts Center, Cincinnati, Ohio
Movement, Hanover Gallery, London

1965 British Section, *4th Biennale des Jeunes Artistes*, Paris
John Moores Exhibition, Walker Art Gallery, Liverpool
Industry and the Artist
The Great Society – A Sampling of its Imagery, Arts Forum, Inc., Haverford, Pennsylvania
A New York Collector Selects, (Mrs Burton Tremaine), San Francisco Museum of Modern Art, San Francisco
The English Eye, Marlborough Gerson, New York
'1 + 1 = 3. Retinal Art', University of Texas, Austin, Texas
Tel Aviv Museum, Israel

1965–66 *The Responsive Eye*, Museum of Modern Art, New York (and tour of USA)
London, The New Scene, Walker Art Center, Minneapolis (also Washington, Boston, Seattle, Vancouver, Toronto and Ottawa)

1966 *English Graphic Art*, Galerie der Spiegel, Cologne
British Painting To-day, Hamburg (organized by B.P. Ltd)
London under 40, Galleria Milano, Milan
Galerie Aujourd'hui, Brussels

1966–67 *Aspects of New British Art* (tour of New Zealand and Australia)
Transatlantic Graphics, organized by Gene Baro, Camden Art Centre and British tour

1967 *Acquisitions of the 60s*, Museum of Modern Art, New York
Bradford City Art Gallery Spring Exhibition

123

Op Art, Londonderry, Dublin and Belfast
Drawing Towards Painting –2, Arts Council, London
English and American Graphics '67, (Museum of Modern Art) Belgrade and
 Yugoslav tour organized by Gene Baro
Premio di Tella, Buenos Aires
Recent British Painting, Peter Stuyvesant Foundation Collection, Tate Gal-
 lery, London
Young British Painters, Brussels
Carnegie International, Pittsburgh
British Drawings, Museum of Modern Art, New York, touring exhibition
 in USA

1968 *Plus by Minus; Today's Half Century*, Albright-Knox Art Gallery Buffalo,
 NY
Young British Generation, Akademie der Kunste, Berlin
Midland Group Gallery, Nottingham
Leicestershire Education Authority Collection Part 2, Whitechapel Art Gallery,
 London
British Kunst Heute, Kunstverein, Hamburg
New Generation Interim Exhibition, Whitechapel Art Gallery, London
British Artists: 6 painters, 6 sculptors, Museum of Modern Art, New York
 exhibition touring USA
Recent British Prints, I.B.M. New York organized by Gene Baro, tour of
 USA
New British Painting and Sculpture, assembled by Whitechapel Art Gallery
 for tour in USA and Canada
English and American Graphics, touring exhibition in England organized by
 Gene Baro
European Painters Today, touring exhibition-Paris, New York, Washington,
 Chicago, Atlanta
Documenta (print section)

1969 *Marks on a Canvas*, Museum am Ostwall, Dortmund, organized by Anne
 Seymour
Contemporary Art: Dialogue between the East and the West, National Museum
 of Modern Art, Tokyo

Represented in the following public collections

GREAT BRITAIN: LONDON

 Arts Council of Great Britain
 British Council
 Calouste Gulbenkian Foundation
 Peter Stuyvesant Foundation
 Tate Gallery
 Victoria and Albert Museum

PROVINCES
Arts Council of Northern Ireland, Belfast
Ferens Art Gallery, Kingston-upon-Hill
Whitworth Art Gallery, Manchester
Walker Art Gallery, Liverpool
Leicestershire Education Authority
Borough of Thornaby-on-Tees

USA Museum of Modern Art, New York
Albright-Knox Art Gallery, Buffalo, NY
Pasadena Museum of Modern Art, California
Santa Barbara Museum, California
Chicago Institute

AUSTRALIA Art Gallery of Victoria, Melbourne
Power Collection, Sydney

Awards

1963 AICA Critics Prize
Prize in Open Section of John Moores Exhibition, Liverpool

1964 Peter Stuyvesant Foundation Travel Bursary to USA

1968 Major Painting Prize, XXXIV Venice Biennale

Bibliography

Statements by the artist

Statement in the New Generation Exhibition catalogue, Whitechapel Art Gallery, London 1964

'Bridget Riley answers questions about her work' *Monad I* London 1964

'Perception is the medium' *Art News* New York, October 1965

'Bridget Riley interviewed by David Sylvester' *Studio International* London, March 1967

'Bridget Riley and Maurice de Sausmarez, a conversation' *Art International* Lugano, April 1967

General bibliography

Gene Baro, 'Bridget Riley: drawing for painting' *Studio International* July 1966

Gene Baro, 'Bridget Riley's Nineteen Greys' *Studio International* December 1968

Jack W. Burnham, 'The Art of Bridget Riley' *Triquarterly* 5 Evanston, Illinois, 1966

Anton Ehrenzweig and David Sylvester *Bridget Riley* (catalogue introduction), Gallery One, London 1963

Anton Ehrenzweig, 'The Pictorial Space of Bridget Riley' *Art International* February 1965

Giuseppe Gatt *Metro* 1968

Kennedy, 'Venice '68' *Art International* September 1968

Robert Kudielka, 'Jensiets von Op Art: Bridget Riley im Gesprach' *Das Kunstwerk* January 1969

Edward Lucie-Smith, 'Round the Galleries, Assemblages' *The Listener* London, 7 February 1963

Norbert Lynton, 'London Letter, Bridget Riley' *Art International* VI/7, Zurich, September 1962

Norbert Lynton, 'London Letter, Riley' *Art International* VII/8, Lugano, October 1964

'Op Art' *Life* LVII/24, 11 December 1964 (illustrations of work)

Jasia Reichardt, 'Bridget Riley' *Architectural Design* 8/354, London, August 1963

Bryan Robertson, 'Bridget Riley Drawings' *Spectator* London, 2 May 1969

Bryan Robertson, 'Bridget Riley' *Spectator*, London, 19 July 1969

John Russell, 'Art News from London, Riley' *Art News* LXII/7, New York, November 1963

John Russell, 'Bridget Riley and Phillip King' *Art in America* New York, May/June 1967

Maurice de Sausmarez *Bridget Riley* (catalogue introduction), Gallery One, London, April 1962

Maurice de Sausmarez *Bridget Riley: working drawings* (catalogue introduction) Bear Lane Gallery, Oxford, April 1969; reprinted in *Art and Artists* London, April 1969

Michael Shepherd, 'Bridget Riley' *The Arts Review* XIV/8, London, May 1962

David Sylvester, 'Bridget Riley' *New Statesman* London, 25 May 1962

David Thompson *Bridget Riley* (catalogue introduction), The New Generation 1964 Exhibition, Whitechapel Art Gallery, London 1964

David Thompson, 'British Artists at Venice: the paintings of Bridget Riley' *Studio International* June 1968

David Thompson *Bridget Riley* (catalogue introduction), Venice Biennale, Venice, June 1968

Acknowledgements

The publishers would like to thank the following for allowing their pictures to be reproduced: firstly Bridget Riley herself, who has been most generous with all pictures within her copyright; Harry N. Abrams; Lex Aitken (pl. 22); The Arts Council of Great Britain (pls 9, 56 and 76); The Art Institute of Chicago (pl. 17); The British Council (pl. 71); Croydon Corporation; Mr and Mrs A. Curtis; Mio Downyck; Eric Estorick (pl. 29); Gallery One, London (pls. 10 and 28); The Richard Feigen Gallery, New York; Dr and Mrs R. J. Fusillo (pl. 42); Calouste Gulbenkian Foundation (pl. 36); Mr and Mrs Paul M. Hirschland, New York (pl. 44); Jasper Johns (pl. 37); Mr and Mrs Robert B. Mayer (pls 5, 6, 31, 61); John Muirhead (pl. 35); The Museum of Modern Art, New York, gift of Philip Johnson (pl. 43); Mr Vernon Nikkel (pl. 11); Philips Industries Inc. (pl. 73); Mr J. Power, Louise Riley; Mrs S. G. Rantbord (pl. 34); Bryan Robertson; Stephen A. Schapiro; Ronald Shaw Kennedy (pl. 81); Mr and Mrs Rudolph B. Shulhof (pl. 50); Peter Stuyvesant Foundation (pls 26 and 52); David Sylvester; The Tate Gallery (pls 3 and 74); Mr and Mrs Burton Tremaine; The Whitworth Art Gallery, University of Manchester (pls 54 and 63); Mr David M. Winton (pl. 39); Mr and Mrs S. Wax; and the National Gallery of Victoria (pl. 13).

Photographs were taken by E. Pollitzer (pls 5, 14, 31, 58, 64); John Webb (pls 24, 25, 63, 71, 76); G. Clements (pl. 37); the Cavendish Studio (pl. 30); and the Grosvenor Gallery (pl. 34).

Index

Arrest III 34, 90, 92, *92; Early study for 'Arrest' series 1967* 95, *95; Study for 'Arrest' series (image B, tonal structure 1)* 95, *95*
Arezzo, Guido d' 27

Bach 26
Balla, Giacomo 10, 18, 27
Baro, Gene 79
Biederman, Charles 61, 120
Black to white discs 24, 29, 59
Blanc, Charles 20, 27, 120
Blaze I 30, 50, *51; Blaze II* 30
Blue landscape 6, 7
Boccioni, Umberto 10, 57, 60
Bonnard, Pierre 26, 28
Botticelli, Sandro 118
Breathe 59, 109, *109*
Brewster 30
Broken circle 30, 48, *49; Study for 'Broken circle'* 48, *48*
Burn 81, 82, *83*
Byzantium 112, *112*

Carpenter H.B. 87, 120
Cast, study for, 1965 56, *56*
Cataract III 100, *101; Cataract V* 102, *103; Cataract* series 87
Cerise, olive and turquoise band study 117, *117*
Cézanne, Paul 16, 57
Chant I 87; *Study for 'Chant I'* 102, *102; Chant* series 88, 112
Chevreul 27, 86
Chill 84
Circle with a loose centre 29, 30
Climax 35, 54, *55*
Continuum 29, 32, *33; Study for 'Continuum'* 32, *33; Panel of 'Continuum'* 33, *33*
Craft, Robert 120
Cresswell, Peter 27
Crest 25, 30, 43, *43*
Culbert, Bill 27
Current 30, 34
Curve study 1966 96, *97*

Degas 60
Delaunay R. 86, 120
Deny II 34, 72, 76, 77, 81, 82; *Deny* series 74
Disfigured circle 46, *47, 48*

Disturbance 72, *73; Untitled study related to 'Disturbance'* 72, *73*
Drift 34, 92, *93*
Dynamic penetration of an automobile 27

Edwards, John 27
Ehrenzweig, Anton 10, 22, 30, 31, 50, 52, 64, 120
Eliot T.S. 10

Fall 8, 9, 30
Feigen, Richard 10, 34
Fission 28, 68, *68*, 89, 90
Fragments no 4 72, *72; no 6* 10, *11*
Fugitive 22, 25

Girl running on a balcony 18

Hauser, Arnold 27
Hayes, Colin 9
Helmholtz 18
Henry, Charles 18, 27
Hering, Ewald 16, 18, 88
Hero (Ascending and Descending) 34, *35*, 37, 109
Hesitate 34, 63
Hidden squares 22, *23*, 29, 64
Homer, William Innes 27
Horizontal vibration study 29, 114, *114, 115*
Hoyland, John 10, 27
Hurvich 88

Ingres J.A.D. 9, 26
Intake 40, *41; Study for 'Intake'* 40, *40*
Interrupted circle 30
Iridescent interpenetration, The 27

Jameson 88
Jones, Allen 10, 27

Kandinsky, Wassily 86
King, Phillip 10
Kiss 16, *17*, 20, 28
Klee, Paul 86

La grande jatte 27
Late morning 18, 24, 27, 87, 90, 104, *104; Study for 'Late morning'* 104, *105*
Le pont de Courbvoie 26
Leclerc, Julien 18
Loss 63

Mach, Ernst 16, 120
Mallarmé 60
Matisse, Henri 26, 86
McKay D.M. 30
Mondrian, Piet 13, 18, 20, 34, 62, 118, 120
Moore, John
Movement in squares 20, 21, 28, 29, 68, 86, 114
Mozart 26
Musgrave, Victor 10, 28

Night watch, The 15
Nineteen greys silkscreen folio 72, 74, 81, 82; *Print A* 79, *79; Print C* 78, *78*

Off 38, *39; Study for 'Off' 1963* (17⅝" x 14¾") 38, *38; Study for 'Off' 1963* (17⅝" x 16½") 38, *38*
Opening 22, 25, *25*, 64
Orient I 87, 106, *106; Study for 'Orient I'* 106, *107; Orient II* 99, 108, *108*, 116; *Orient* series 109

Pale blue, magenta and green, study 112, *112*
Pale magenta, blue and green band study 117, *117*
Pasmore 9
Pause 70, *71*, 84, 96
Persephone I, study for *2*
Piché, Roland 27
Piero della Francesca 16, 27
Pink landscape 9, 18, *19*, 27
Poggendorff 18
Pollock, Jackson 34, 62, 89
Popper, Frank 120

Rabin, Sam 9
Red crossing turquoise elongated triangle study 99, *99*
Rembrandt 15
Remember 63
Rise I 87, *110*, 111, *111*
Robertson, Bryan 118
Rothko 90
Russell, John 68

Sausmarez, Maurice de 9, 10
Search 24, 34, *80, 81*
Sedgeley, Peter 29
Seitz, William 34, 62
Seuphor M. 120
Serif 25, 42, *42*
Serusier, Paul 20, 120

Seurat, Georges 18, 26, 27, 31, 57, 86
Severini, Gino 26, 27
Shift 66, 67, 89; *Scale study for 'Shift' 1963* 66, *66; Study for 'Shift' 1963* 66, 66
Shiver 81, *81*, 89
Shuttle 30, 55, *55*
Signac, Paul 18, 86
Static I 72, 74, *75; Study for 'Static II'* 74, *74*
Stocker, Neil 27
Straight curve 22, 64, 84, 90,
Stravinsky 30, 120
Study 1963 36, 37
Study 1965 64
Study of dark green bands crossed by magenta 116, *116*
Study of light green bands crossed by rose, lilac and orange 116, *116*
Study using cerise, turquoise and olive bands 118, *119*
Structural and tonal movement in opposition 82, *82*
Sylvester, David 30, 76

Thompson, David 27, 46, 90, 120
Thompson J. Walter 9, 10
Thompson, Silvanus 18, 30
Thubron, Harry 9, 87
Tremor 22, 25, 29, 64, *65*
Turn 81, 84, *85*, 89
Turquoise and red study 98, *99*
Twist 52, *53*, 54, 55

Uneasy centre 30, 44, *45*
Untitled 1961 27, *27*
Untitled early colour study 1965 96, *96*
Untitled study 1963 52, *52*
Untitled study 1965 (13 3/16" x 20") 84, *84*
Untitled study 1965 (29⅜" x 17½") 62, *62*
Untitled study 1966 100, *100*
Untitled study 1967 98, *99*
Untitled study for print 1964 37, *37*

Van Gogh 9
Vasarely 28, 34, 68, 88, 89

Where 63, 70, *70*
White discs I 12, *13; Study for 'White discs'* 12, *12*
Woodham, John 27
Wright W.D. 88, 120